WHY WE MARCH

WHY WE MARCH

SIGNS OF PROTEST AND HOPE

Voices from the Women's March

ARTISAN | **NEW YORK**

Cover photographs by the following: Front cover, from top: Teresa Kroeger/FilmMagic/Getty
Images, Curtis Means/ACE Pictures/Newscom, Erik McGregor/Pacific Press/LightRocket via
Getty Images, Stephanie Keith/Reuters, JOSHUA LOTT/AFP/Getty Images, Curtis Means/ACE
Pictures/Newscom, Stephanie Keith/Reuters. Back cover: Top row, from left: Dan Kitwood/Getty
Images, Sam Simmonds/Polaris, Branden Eastwood/Redux, Natan Dvir/Polaris Images. Middle
row, from left: Christophe Morin/IP3/Getty Images, Jessica Brandi Lifland/Polaris, Ron Haviv/
VII/Redux, Natan Dvir/Polaris Images. Bottom row, from left: Theresa Scarbrough, Jess HURD/
REPORT DIGITAL-REA/Redux, Annabel Clark/Redux, Elaine Thompson/AP Photo.

For interior photography credits, see page 260, which functions as an extension of this page.

Library of Congress Cataloging-in-Publication Data is on file.
ISBN 978-1-57965-828-1

Design by Renata Di Biase

Photo editing and research by Look See Photo

Artisan books are available at special discounts when purchased in bulk for premiums and sales
promotions as well as for fund-raising or educational use. Special editions or book excerpts also
can be created to specification. For details, contact the Special Sales Director at the address
below, or send an e-mail to specialmarkets@workman.com.

Published by Artisan
A division of Workman Publishing Co., Inc.
225 Varick Street
New York, NY 10014-4381
artisanbooks.com

Artisan is a registered trademark of Workman Publishing Co., Inc.

Published simultaneously in Canada by Thomas Allen & Son, Limited

Printed in the United States

First printing, February 2017

10 9 8 7 6 5 4 3 2 1

To those
who marched
and those who
continue to
march

Introduction

On January 21, 2017, millions of women and men around the world gathered for the Women's March. They marched in all fifty states. On all seven continents. Across the National Mall in Washington, DC, through the Karura Forest in Nairobi, and alongside penguins in Paradise Bay, Antarctica. Together they formed one of the largest demonstrations in political history, and photographs of the signs they carried quickly circulated across the globe.

Collected here are hundreds of signs from that day, each one offering a unique and moving answer to the question "Why do *you* march?" There are mothers marching for the legacy they wish to leave their daughters. Grandmothers proclaiming "I can't believe I still have to protest this shit." Immigrants marching for their right

to live within our borders, and women and men of color marching for their safety and equality within the same. A little boy proudly stating "I march for my mum and all my friends that are girls," and two little girls holding hands and celebrating "GRL PWR." Many took to the streets to defend their reproductive rights and access to affordable health care; others were moved by the ever-growing threat of climate change.

From the messages on their signs to the pink hats on their heads, the fire in their eyes to the smiles on their faces, the vibrant, diverse participants photographed on this day paint a striking portrait of the Women's March—a groundswell of resistance, love, and hope—and inspire us all to keep marching on.

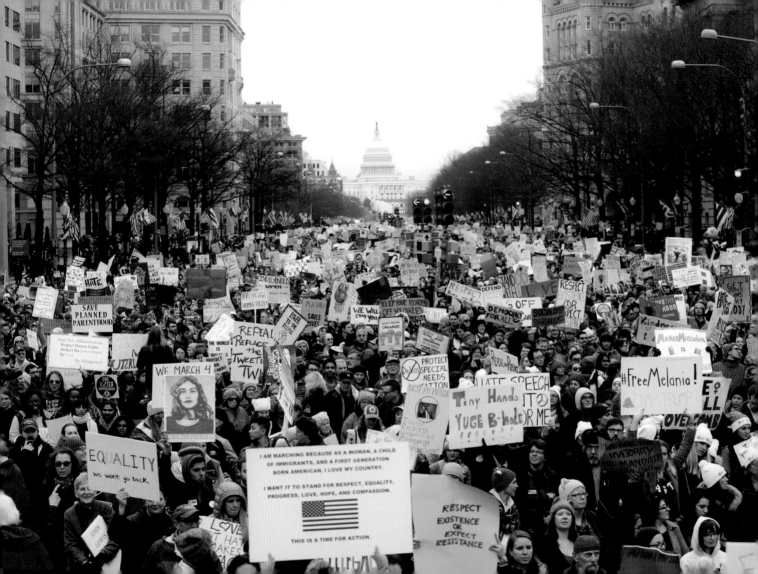

"Remember, the Constitution doesn't begin with 'I the President.' It begins with 'We the People.'"

—Gloria Steinem

TORONTO
PRECEDING: WASHINGTON, DC

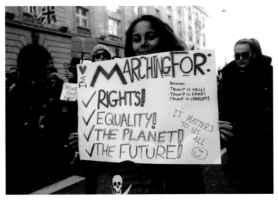

LONDON

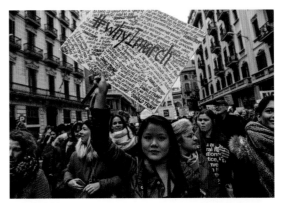

BARCELONA

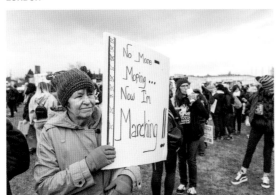

SEATTLE

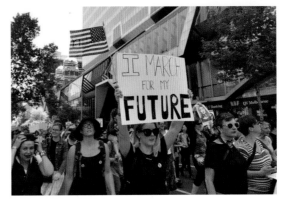

MELBOURNE

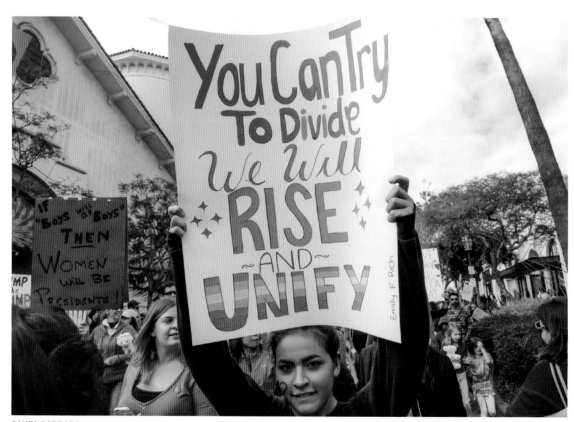

SANTA BARBARA

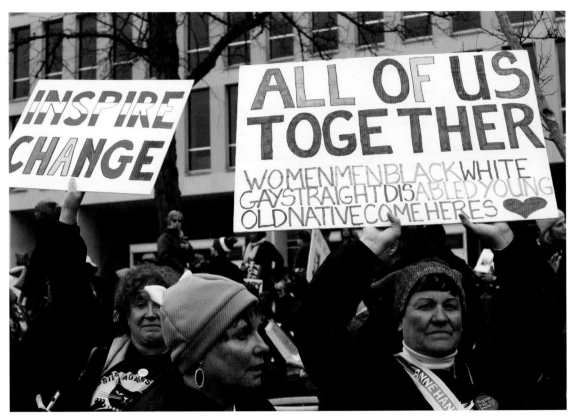

INSPIRE CHANGE

ALL OF US TOGETHER

WOMEN MEN BLACK WHITE GAY STRAIGHT DISABLED YOUNG OLD NATIVE COME HERES ♥

WASHINGTON, DC

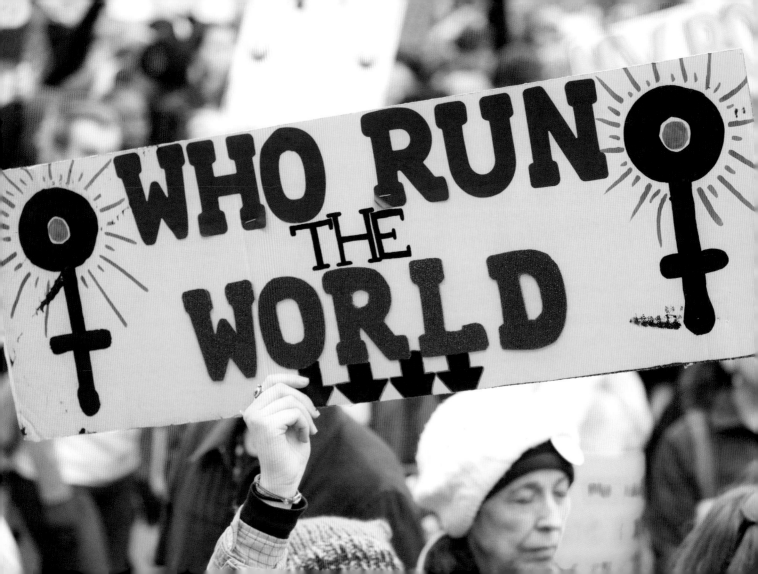

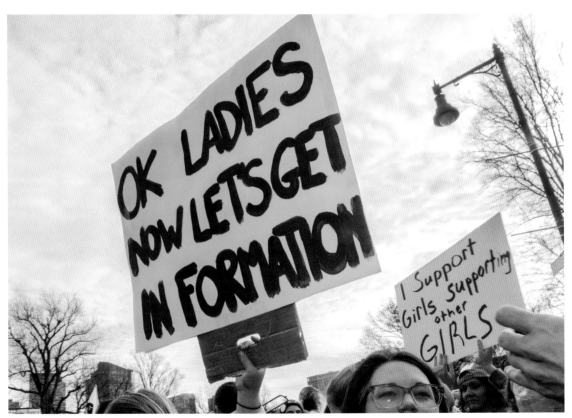

BOSTON
OPPOSITE: WASHINGTON, DC

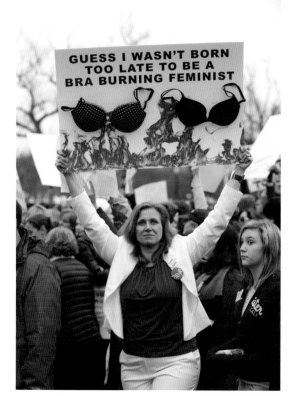

WASHINGTON, DC

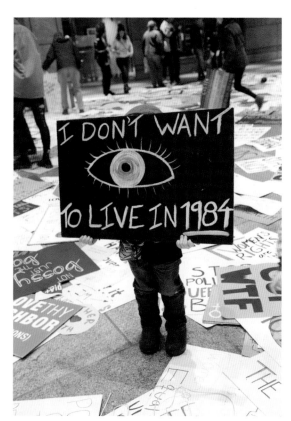

WASHINGTON, DC

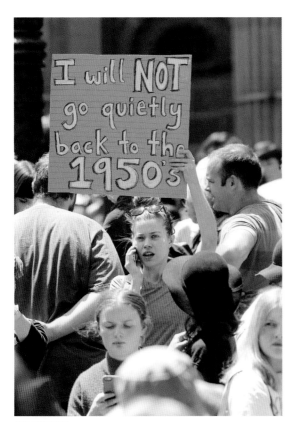

MELBOURNE

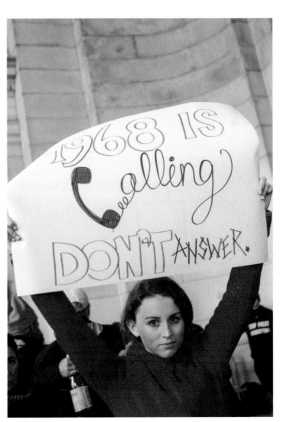

WASHINGTON, DC

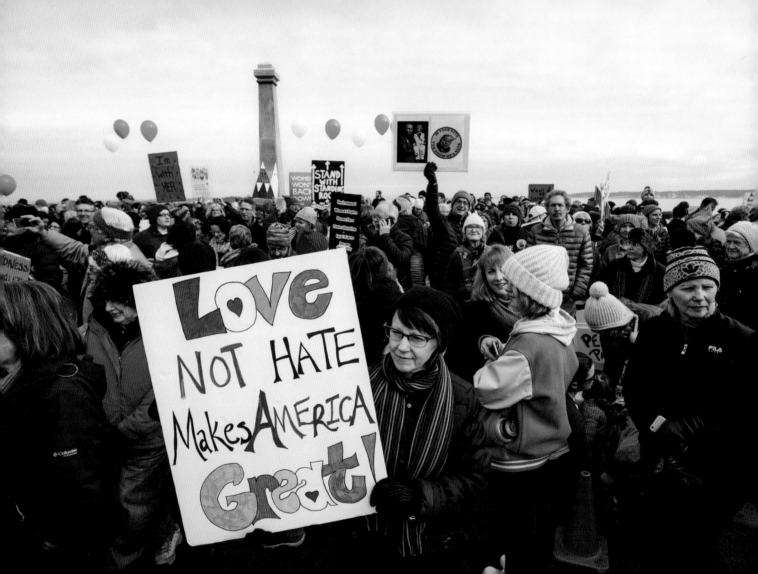

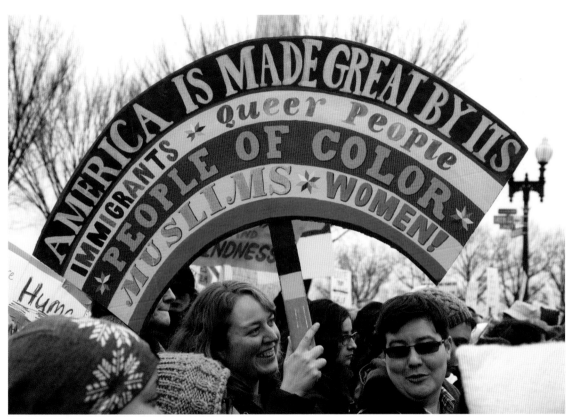

AMERICA IS MADE GREAT BY ITS
queer people
IMMIGRANTS * PEOPLE OF COLOR *
MUSLIMS * WOMEN!

WASHINGTON, DC
OPPOSITE: PORTLAND, ME

"Remember what it feels like. We want you to know you are a part of history right now. You are a part of a global uprising."
—Deb Parent, Women's March co-organizer

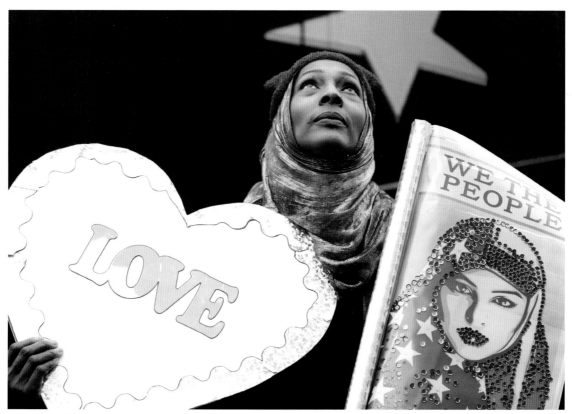

WASHINGTON, DC

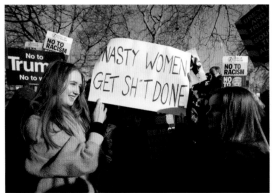

LONDON

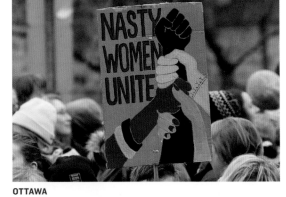

OTTAWA

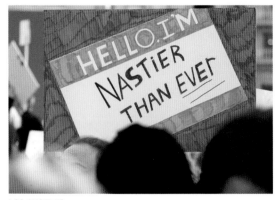

LOS ANGELES

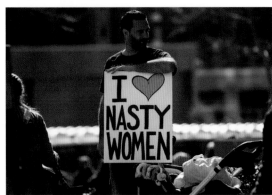

LOS ANGELES

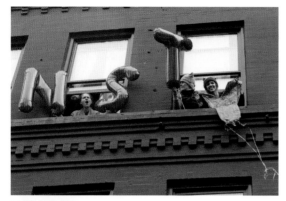

PORTLAND, OR

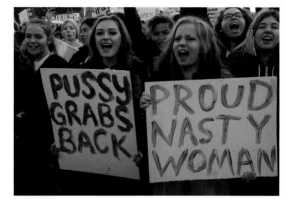

TUCSON

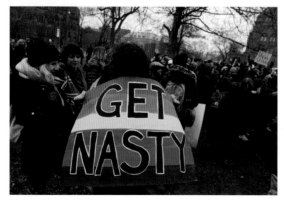

TORONTO

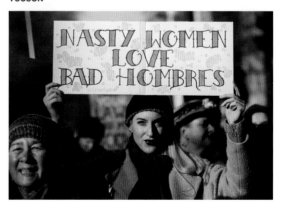

LONDON

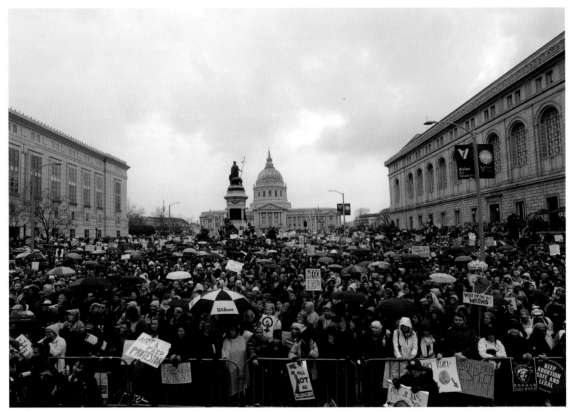

SAN FRANCISCO
OPPOSITE: RENO, NV

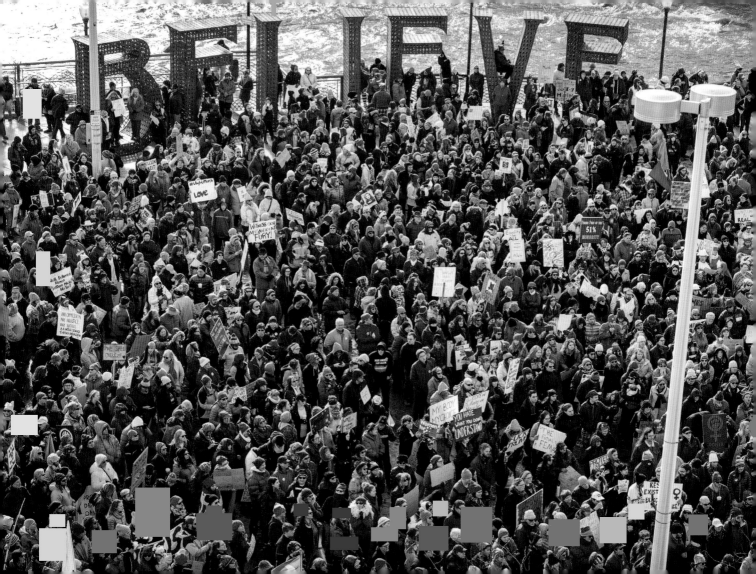

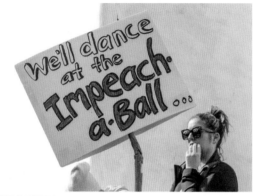

SANTA BARBARA

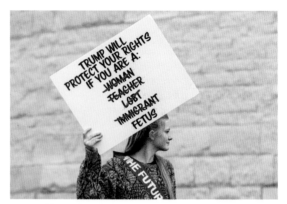

WASHINGTON, DC

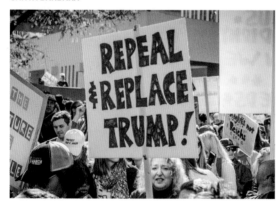

LOS ANGELES

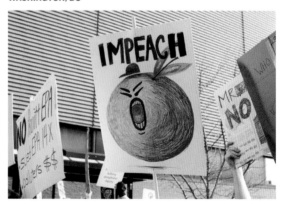

SEATTLE

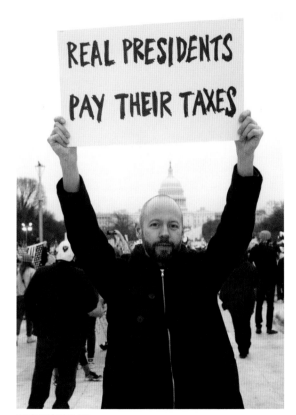

WASHINGTON, DC

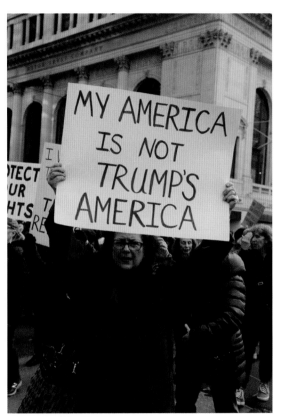

NEW YORK CITY

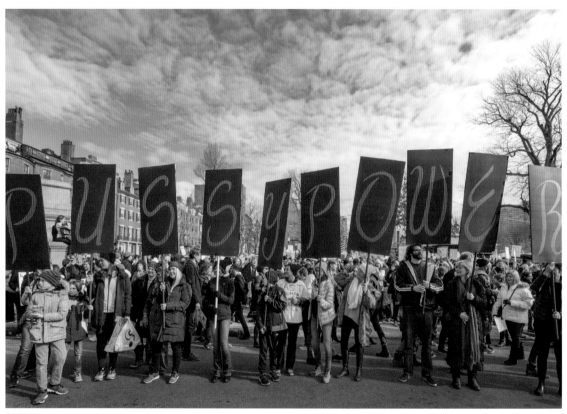

BOSTON

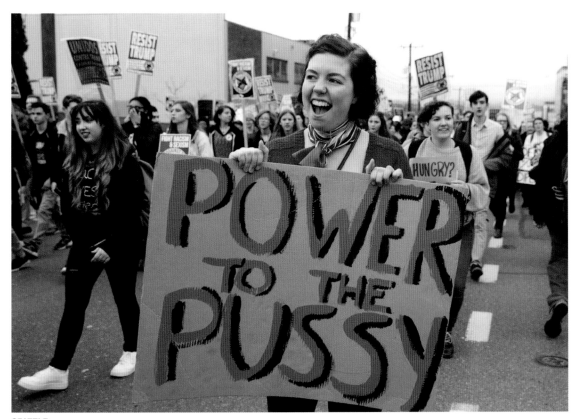

SEATTLE

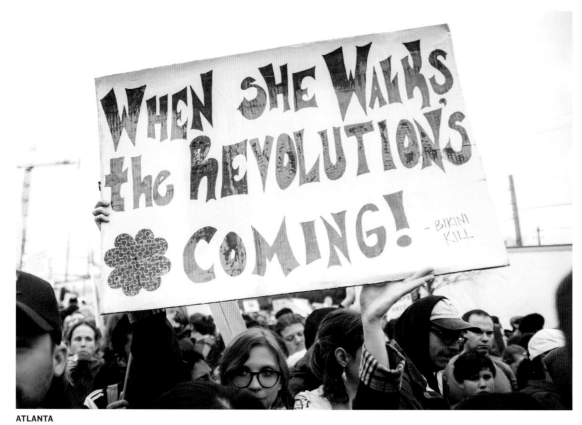

ATLANTA

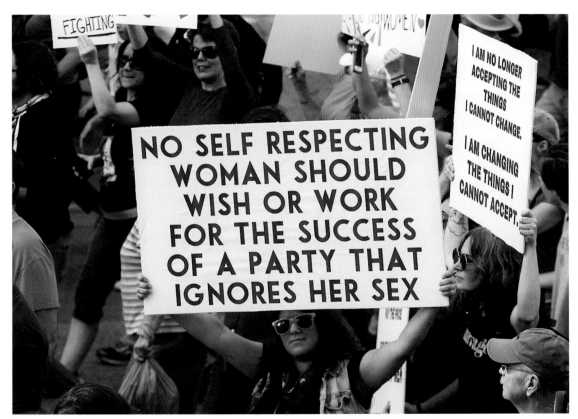

FIGHTING

NO SELF RESPECTING WOMAN SHOULD WISH OR WORK FOR THE SUCCESS OF A PARTY THAT IGNORES HER SEX

I AM NO LONGER ACCEPTING THE THINGS I CANNOT CHANGE.

I AM CHANGING THE THINGS I CANNOT ACCEPT.

AUSTIN, TX

"We can whimper. We can whine. Or we can fight back. We come here to stand shoulder to shoulder to make clear: We are here. We will not be silent. We will not play dead. We will fight for what we believe in!"
—Senator Elizabeth Warren

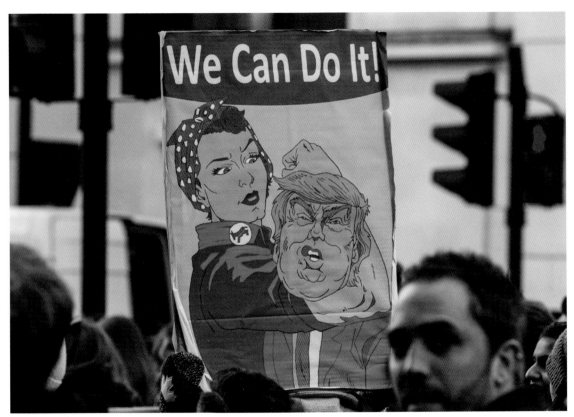

LONDON

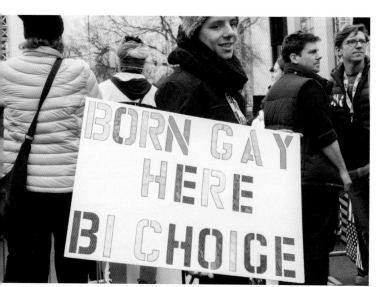

WASHINGTON, DC

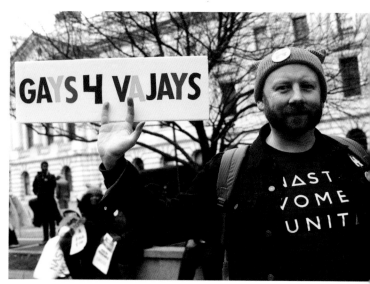

WASHINGTON, DC

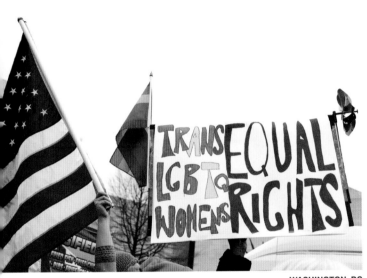

WASHINGTON, DC

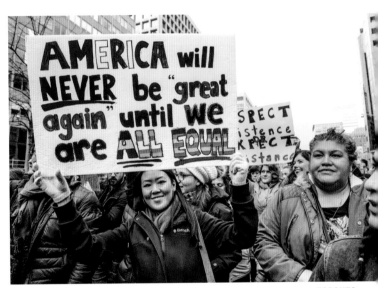

TORONTO

35

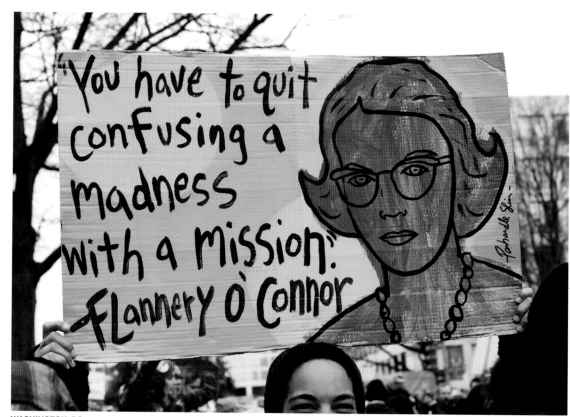

WASHINGTON, DC

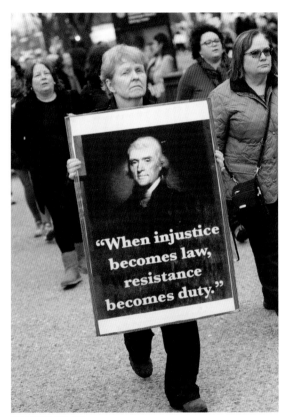

WASHINGTON, DC

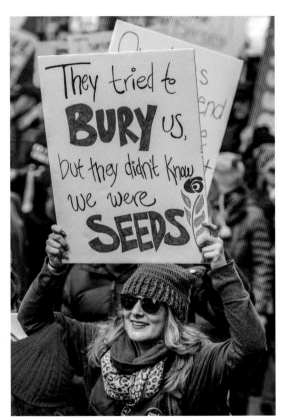

NEW YORK CITY

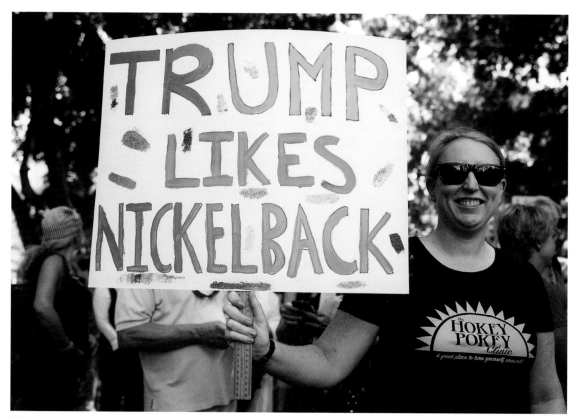

SYDNEY

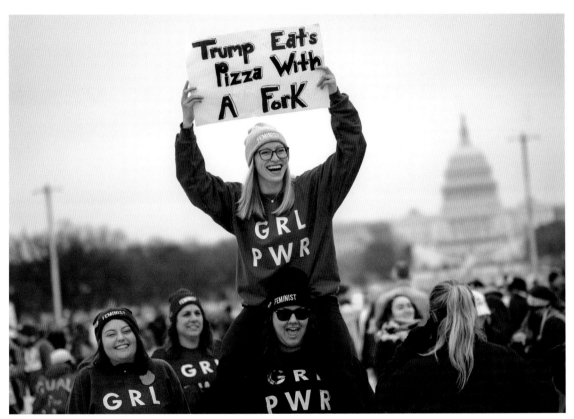

WASHINGTON, DC

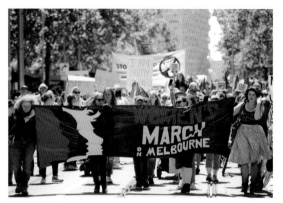

MELBOURNE

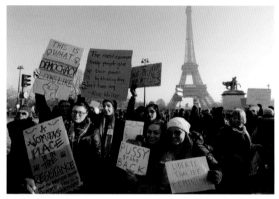

PARIS

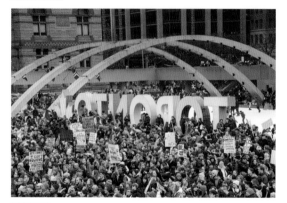

TORONTO

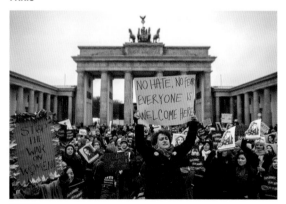

BERLIN

ROME

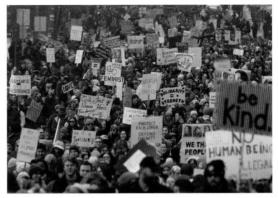

OTTAWA

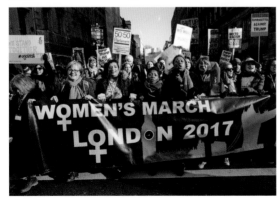

LONDON

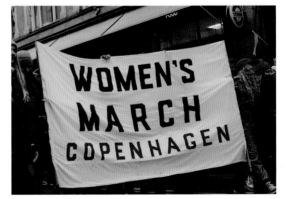

COPENHAGEN

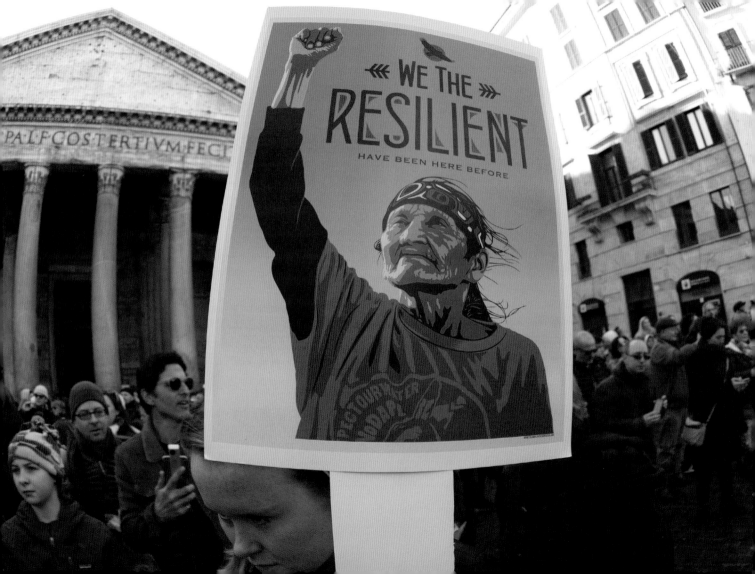

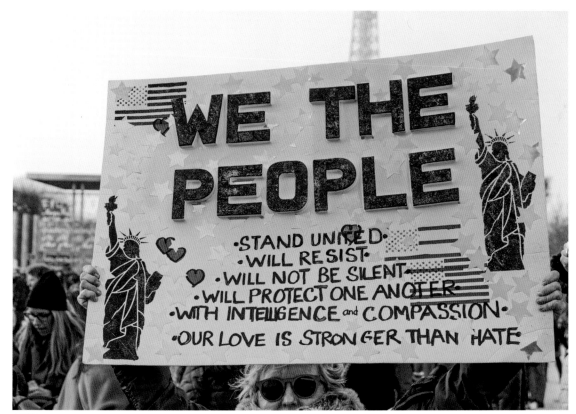

WE THE PEOPLE

•STAND UNITED•
•WILL RESIST•
•WILL NOT BE SILENT•
•WILL PROTECT ONE ANOTHER•
•WITH INTELLIGENCE and COMPASSION•
•OUR LOVE IS STRONGER THAN HATE

PARIS
OPPOSITE: ROME

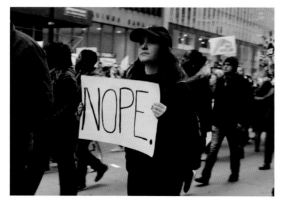

NEW YORK CITY

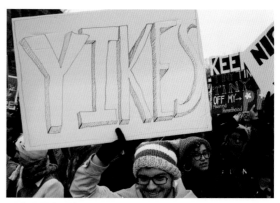

WASHINGTON, DC

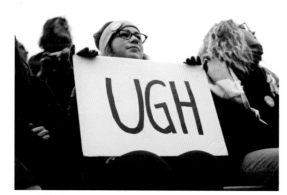

WASHINGTON, DC

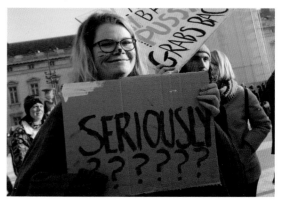

PARIS

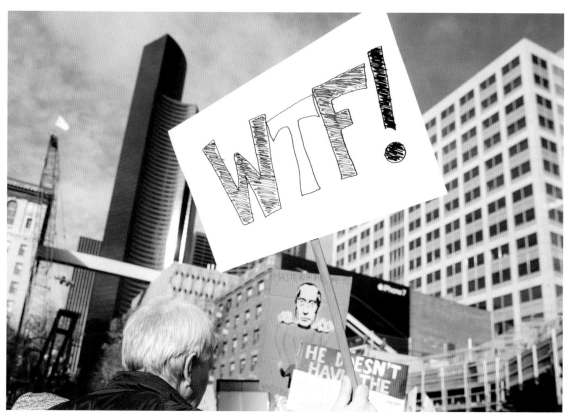

SEATTLE

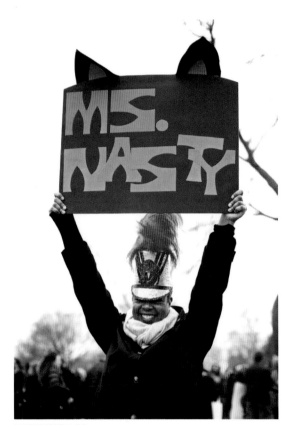

WASHINGTON, DC

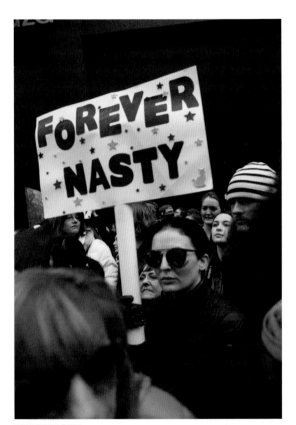

NEW YORK CITY

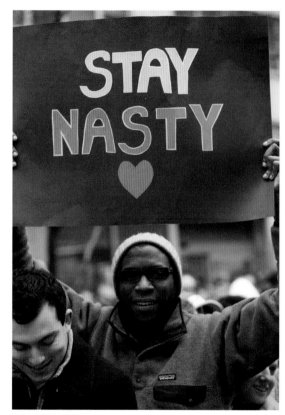

NEW YORK CITY

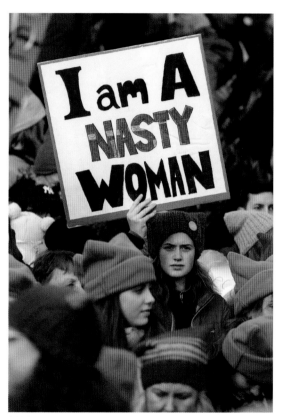

SEATTLE

"Together we are creating a resounding statement, a statement that stakes a claim on our lives and our loves, our bodies and our babies, our identities and our ideals."
—Janet Mock

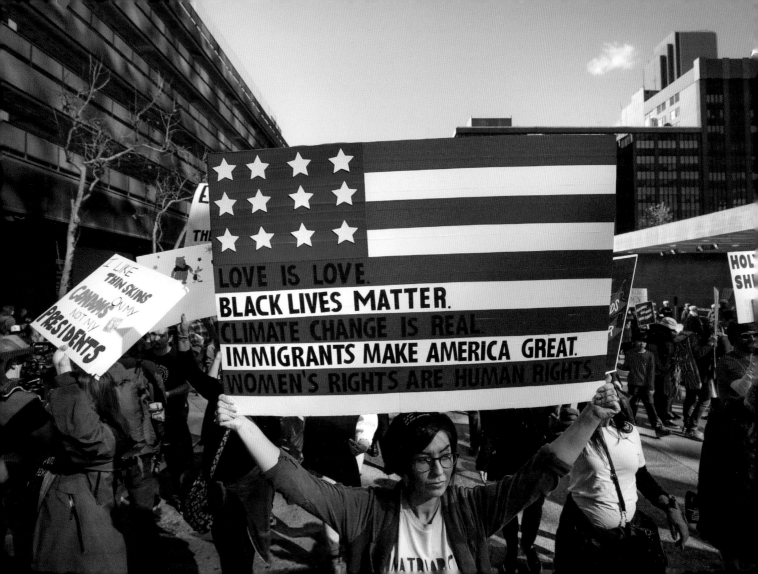

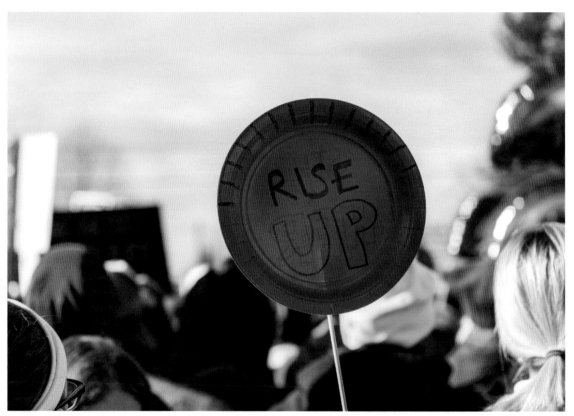

SEATTLE
PRECEDING: LOS ANGELES

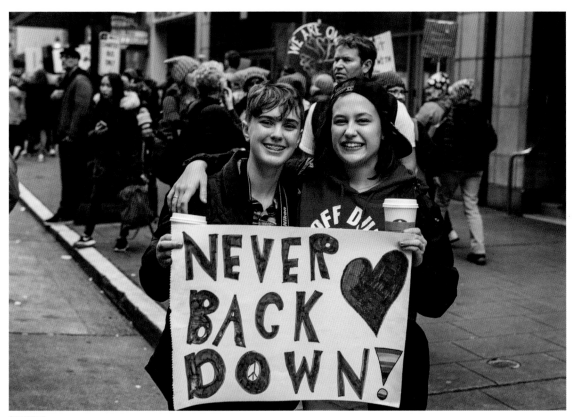

SEATTLE

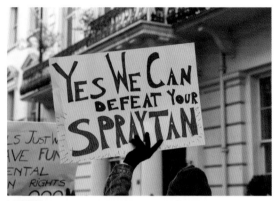

LONDON

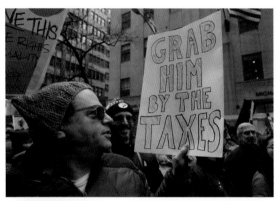

NEW YORK CITY

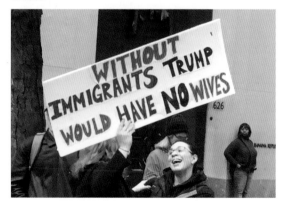

NEW YORK CITY

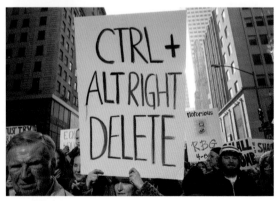

NEW YORK CITY
OPPOSITE: WASHINGTON, DC

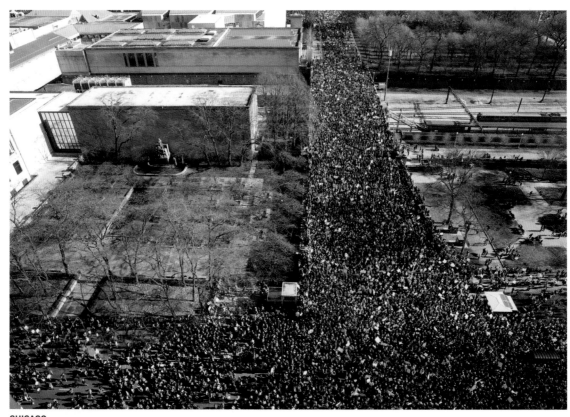

CHICAGO
OPPOSITE: HONOLULU

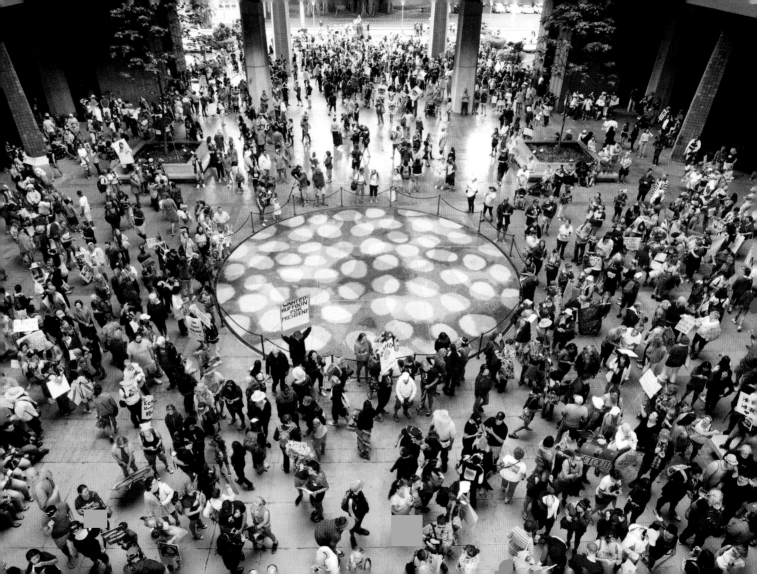

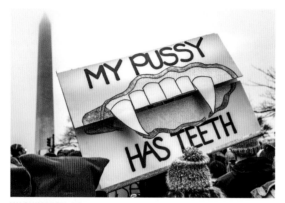

WASHINGTON, DC

OTTAWA

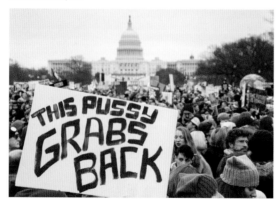

WASHINGTON, DC

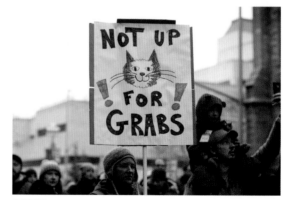

OTTAWA

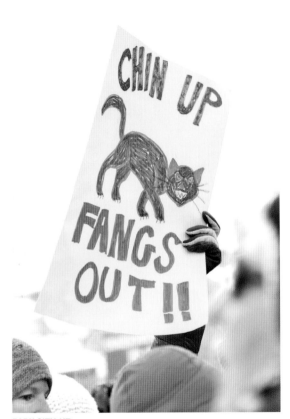

PARK CITY, UT

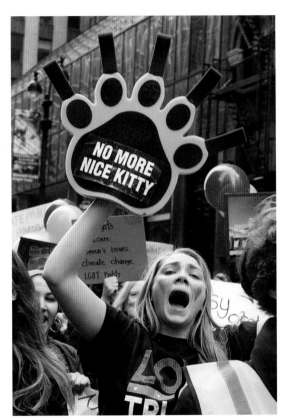

LOS ANGELES

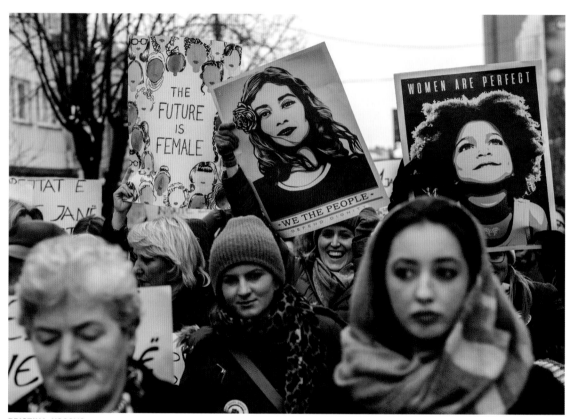

PRISTINA, KOSOVO

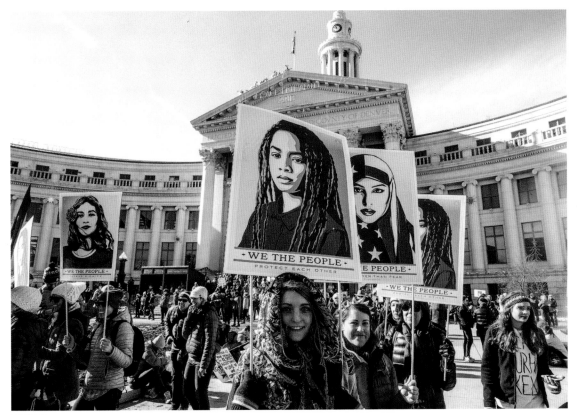

DENVER

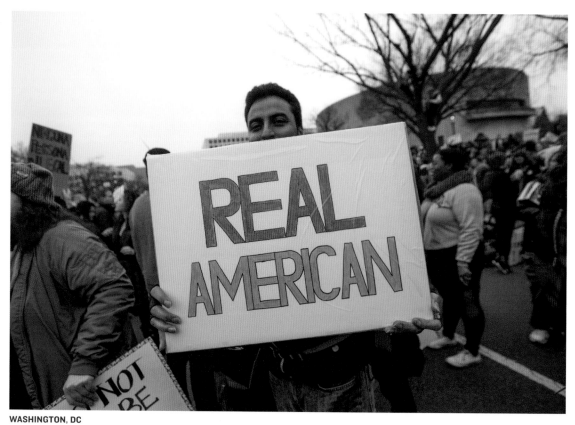

WASHINGTON, DC

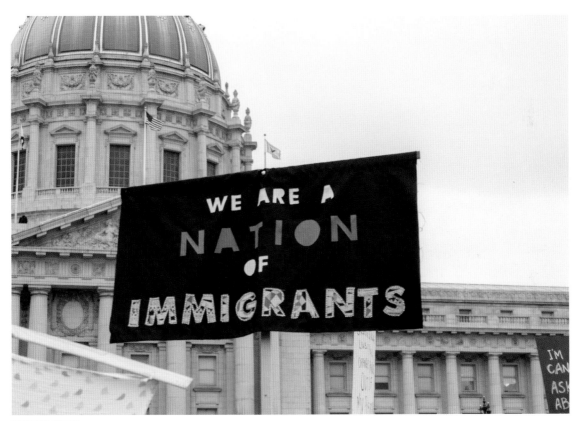

SAN FRANCISCO

"This country's history cannot be deleted."
—Angela Davis

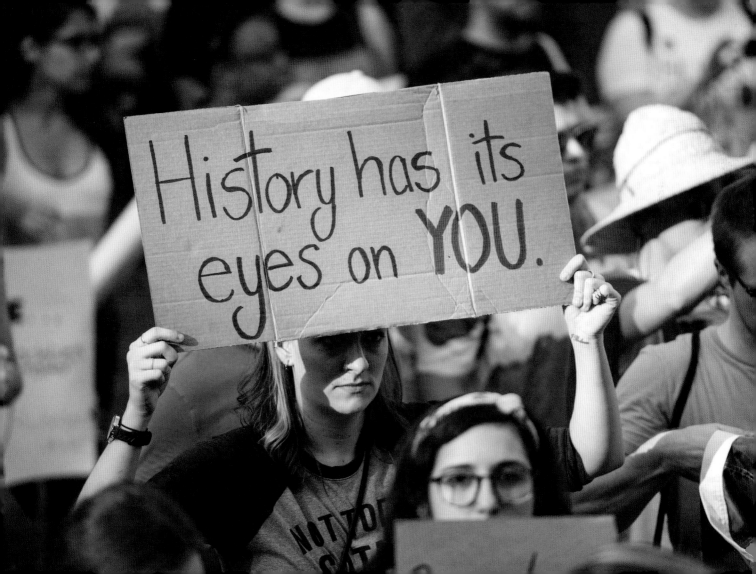

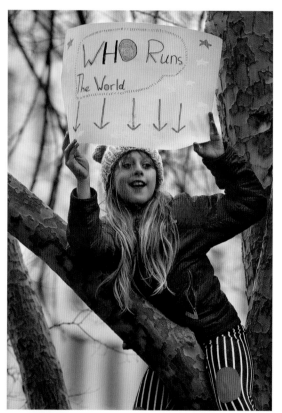

WASHINGTON, DC
PRECEDING: NEW ORLEANS

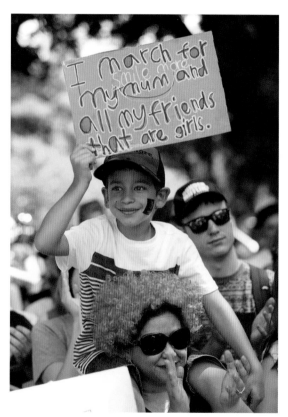

SYDNEY
OPPOSITE: WASHINGTON, DC

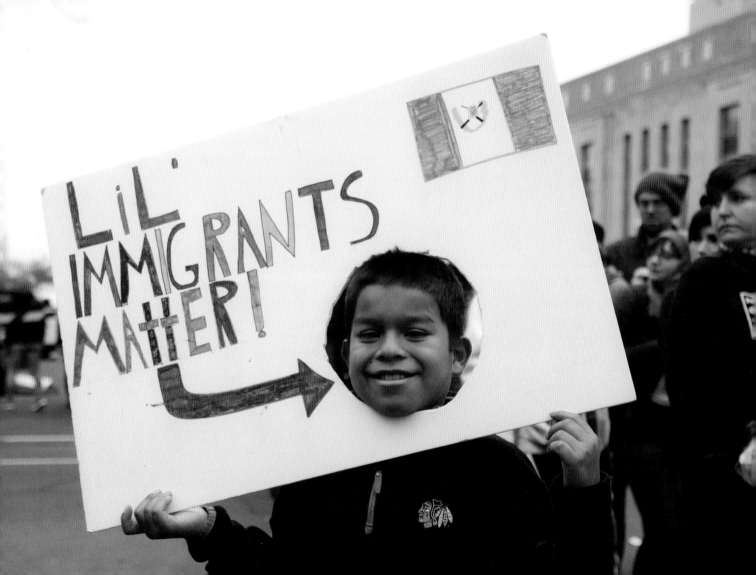

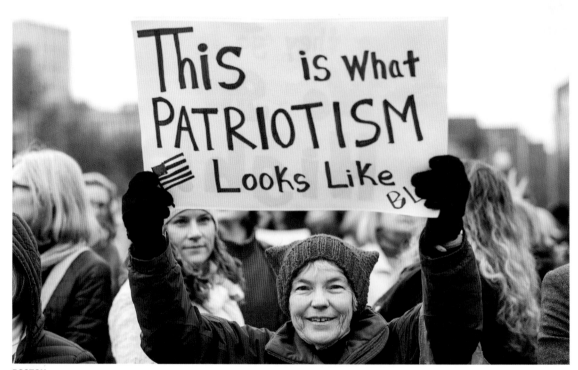

BOSTON

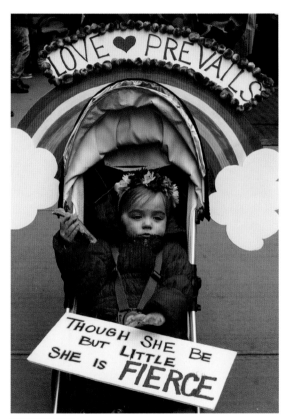

NEW YORK CITY

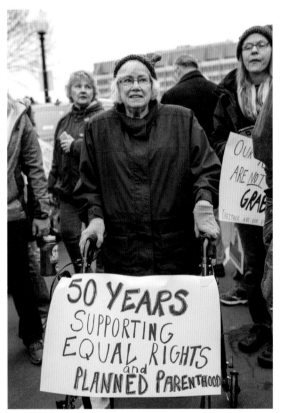

WASHINGTON, DC

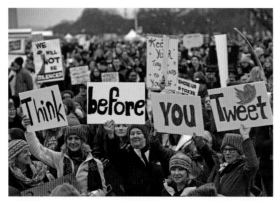

WASHINGTON, DC

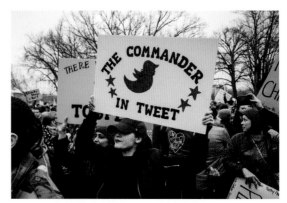

WASHINGTON, DC

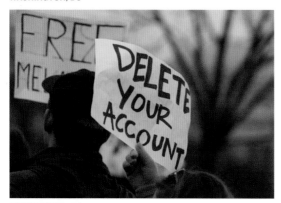

WASHINGTON, DC

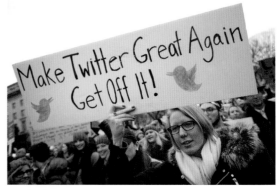

WASHINGTON, DC

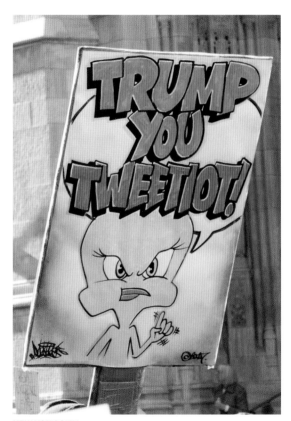

NEW YORK CITY

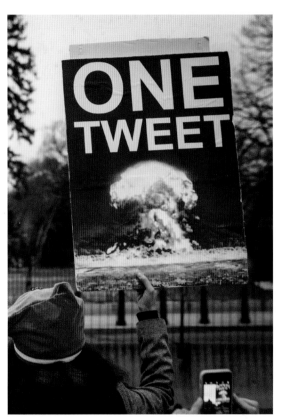

WASHINGTON, DC

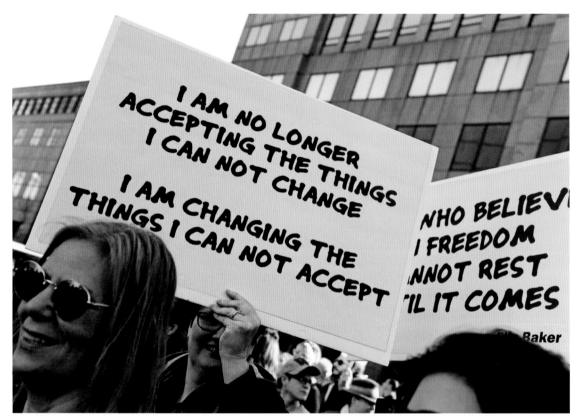

CLEVELAND, OH

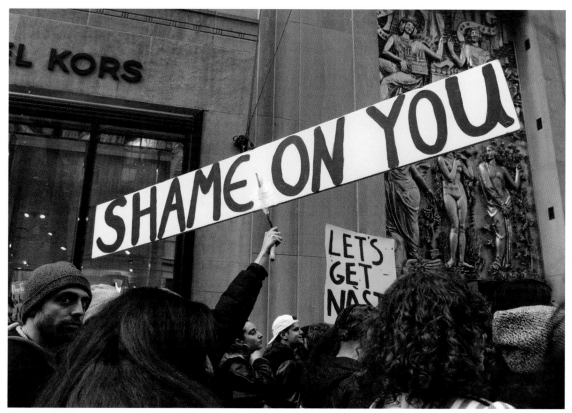

NEW YORK CITY

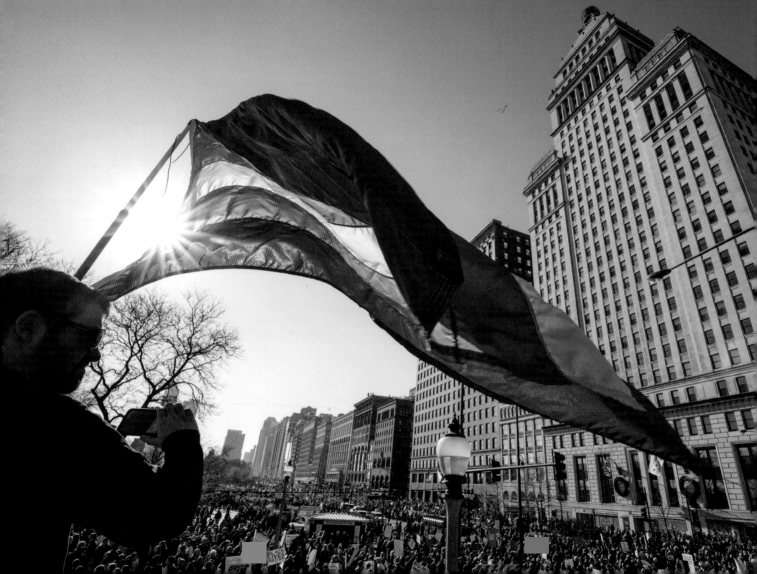

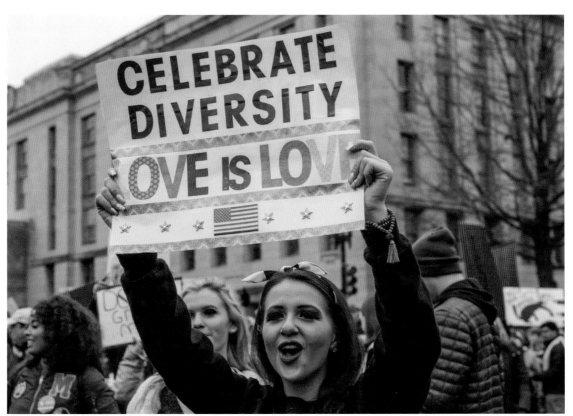

WASHINGTON, DC
OPPOSITE: CHICAGO

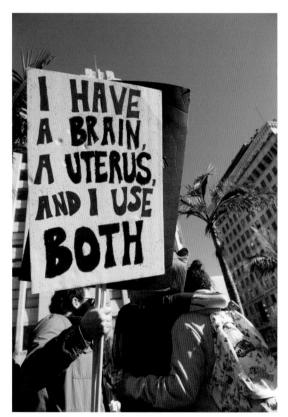

LOS ANGELES

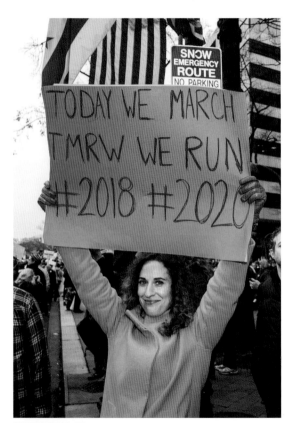

WASHINGTON, DC
OPPOSITE: BOSTON

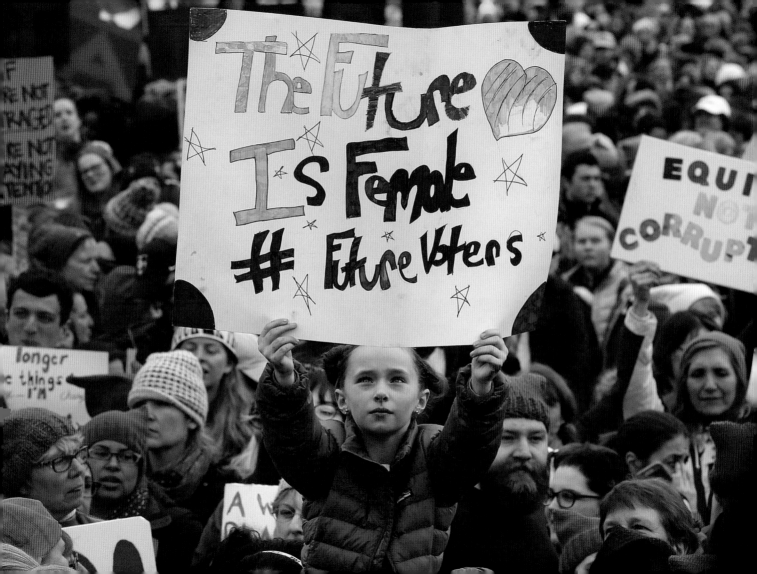

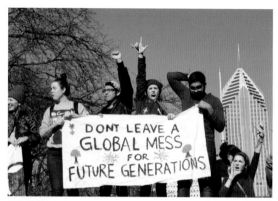

CHICAGO

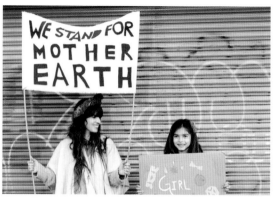

LOS ANGELES

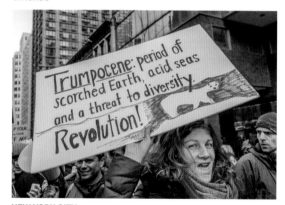

NEW YORK CITY

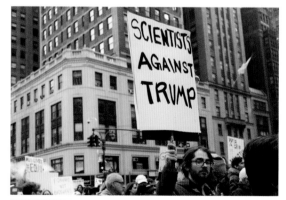

NEW YORK CITY

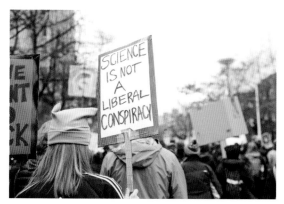

SEATTLE

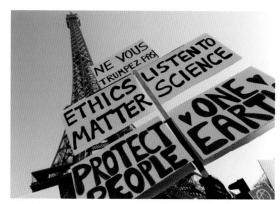

PARIS

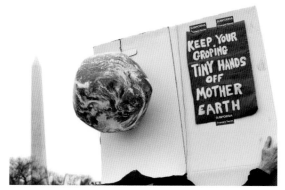

WASHINGTON, DC

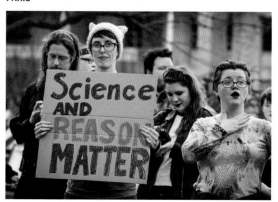

INDIANAPOLIS

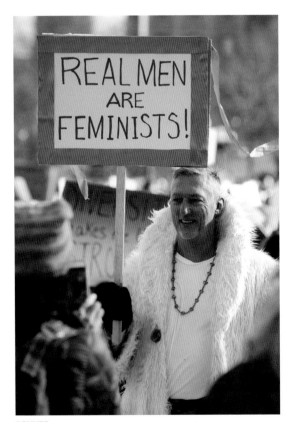

DENVER

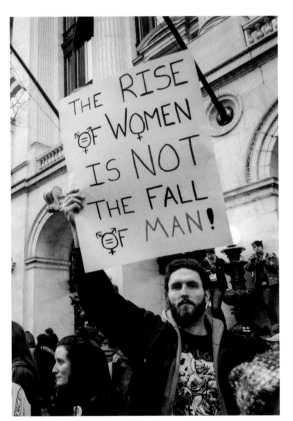

WASHINGTON, DC

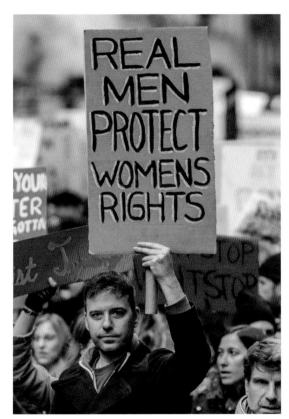

NEW YORK CITY

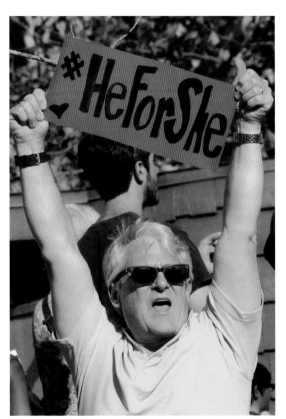

ORLANDO

79

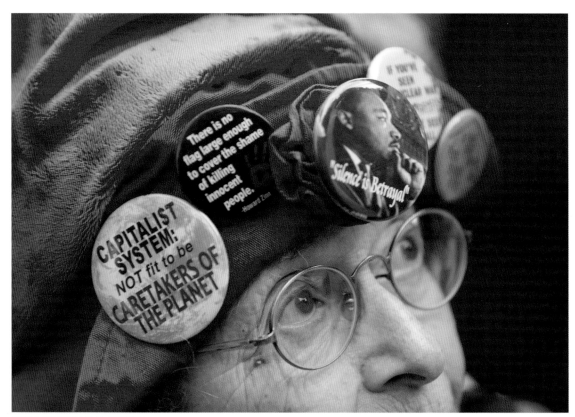

ABOVE AND OPPOSITE: SEATTLE

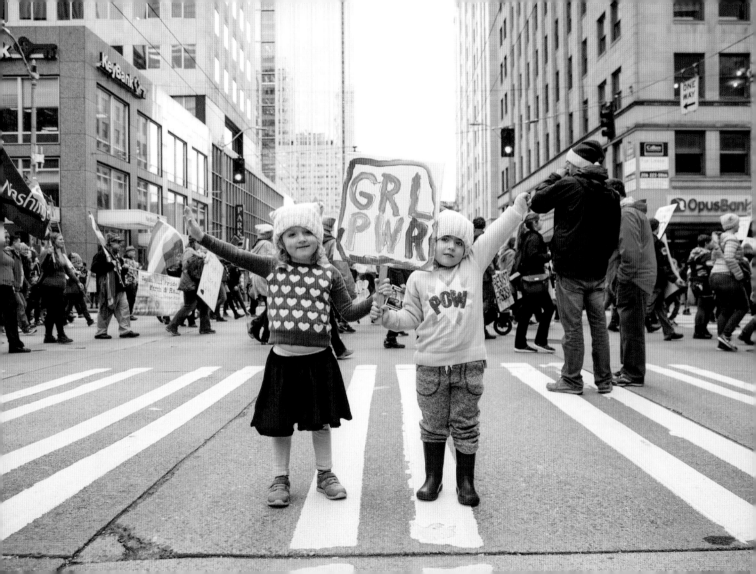

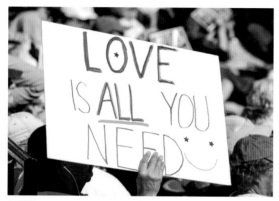

MIAMI

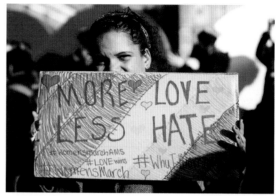

AMSTERDAM

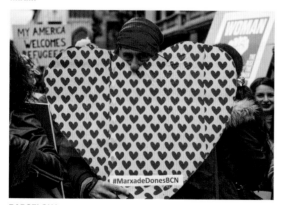

BARCELONA

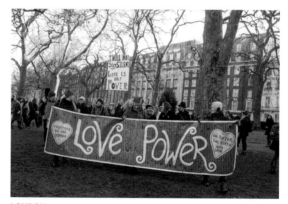

LONDON

"Let us fight with love, faith, and courage so that our families will not be destroyed."
—Sophie Cruz

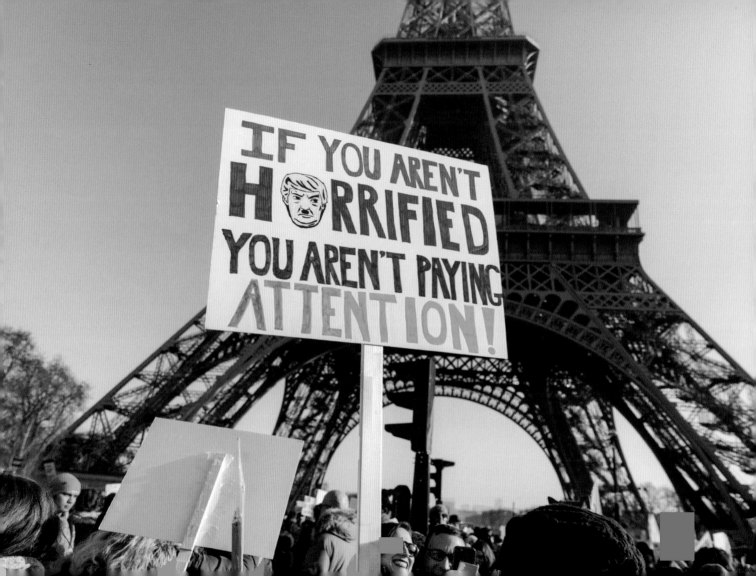

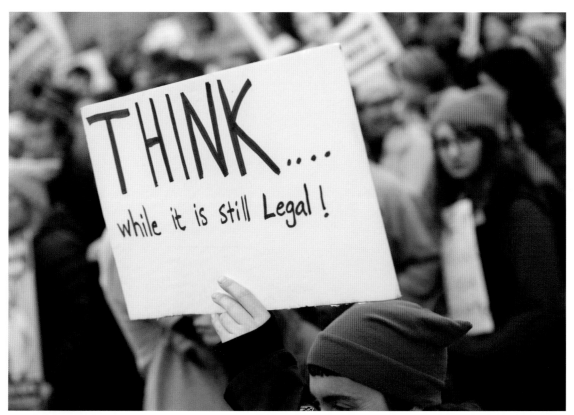

WASHINGTON, DC
OPPOSITE: PARIS

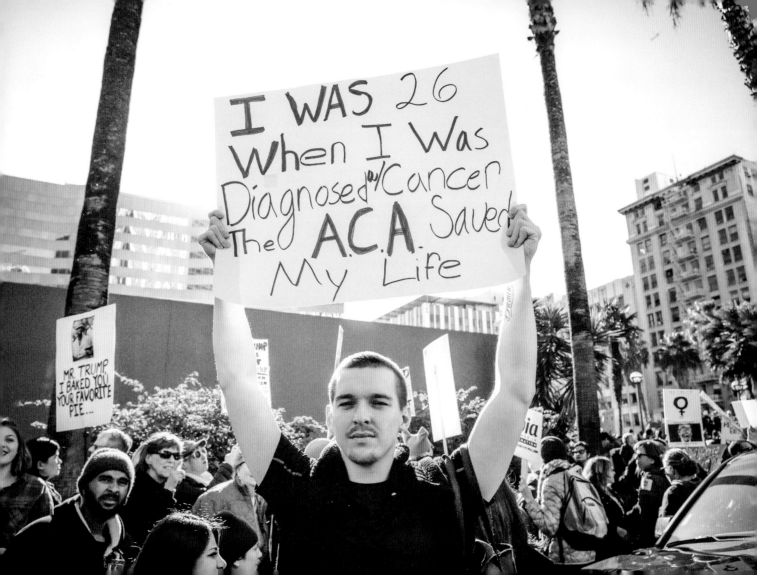

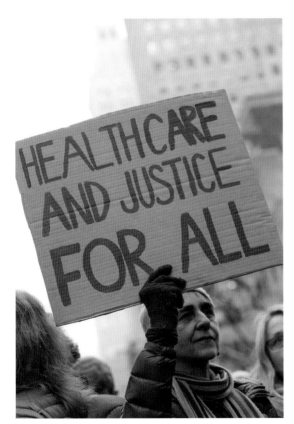

NEW YORK CITY
OPPOSITE: LOS ANGELES

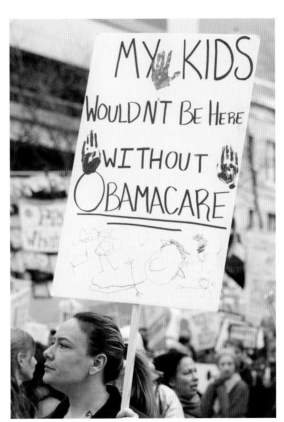

SEATTLE

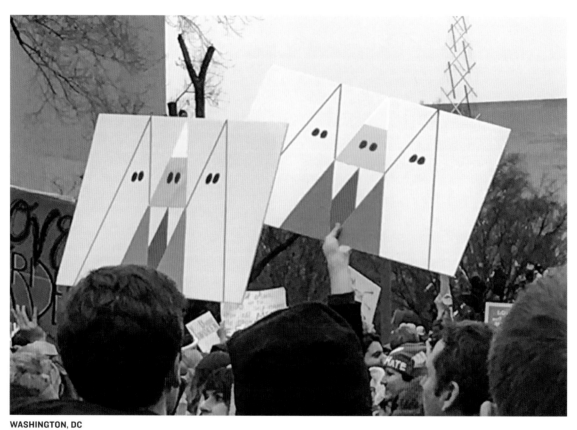

WASHINGTON, DC

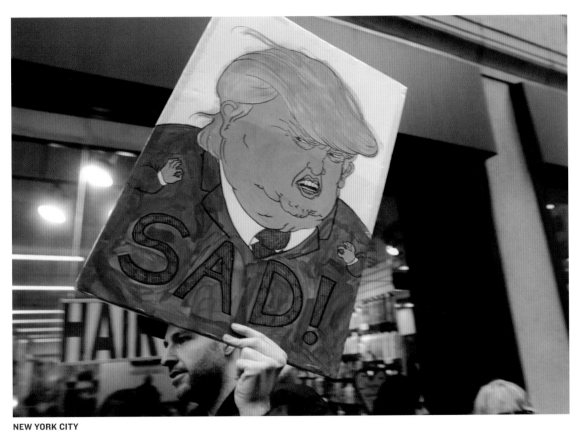

NEW YORK CITY

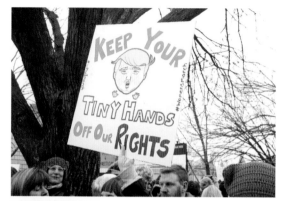

WASHINGTON, DC

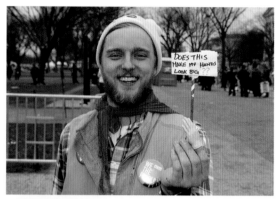

WASHINGTON, DC

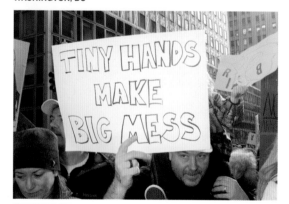

NEW YORK CITY

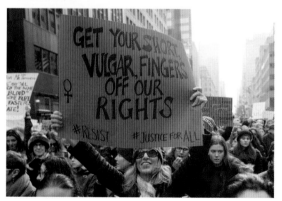

NEW YORK CITY

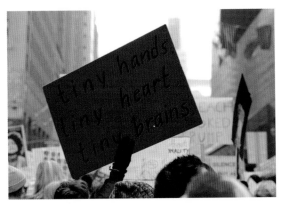

NEW YORK CITY

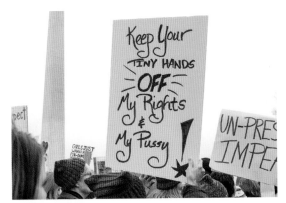

WASHINGTON, DC

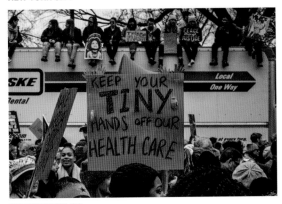

WASHINGTON, DC

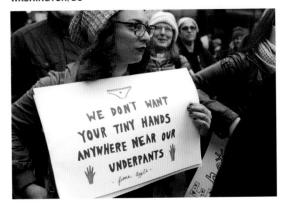

NEW YORK CITY

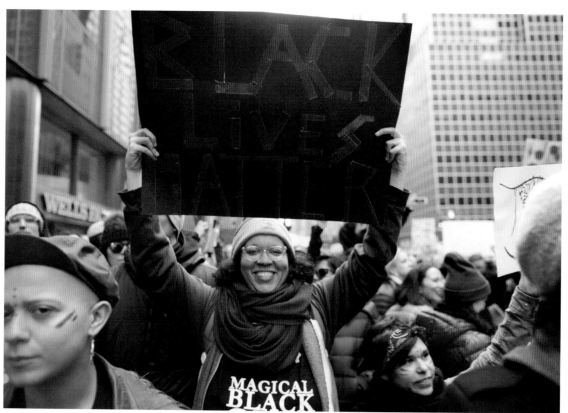

NEW YORK CITY

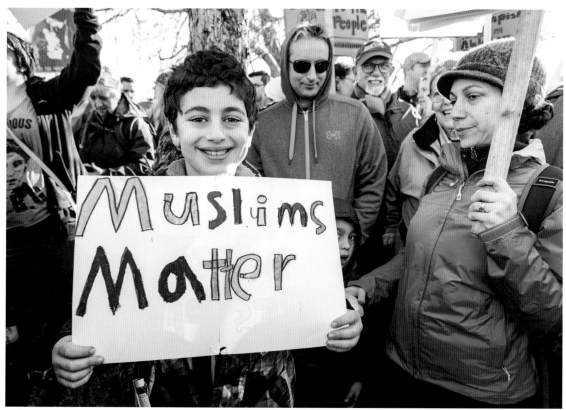

SEATTLE

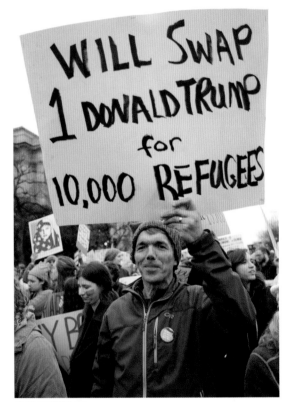

WASHINGTON, DC

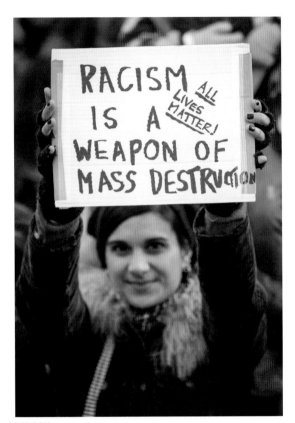

LONDON

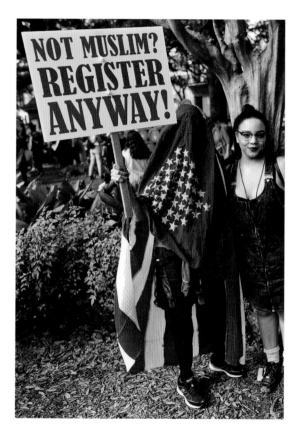

NEW ORLEANS

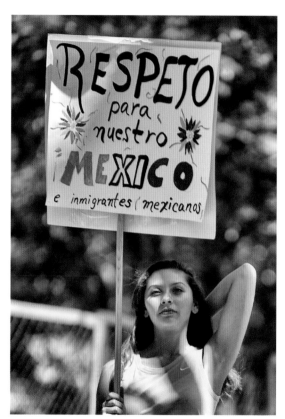

MEXICO CITY

"We are mothers. We are caregivers. We are artists. We are activists. We are entrepreneurs, doctors, leaders of industry and technology. Our potential is unlimited. We rise."
—Alicia Keys

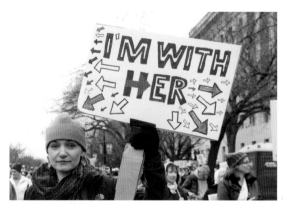

WASHINGTON, DC

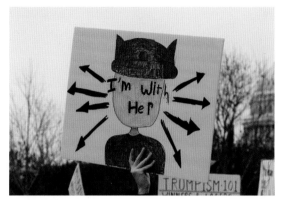

WASHINGTON, DC

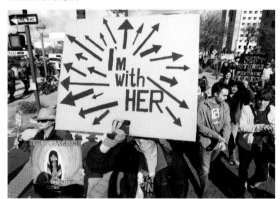

PHOENIX

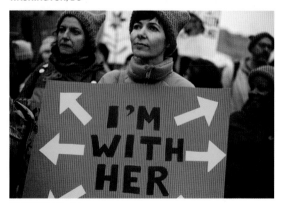

WASHINGTON, DC

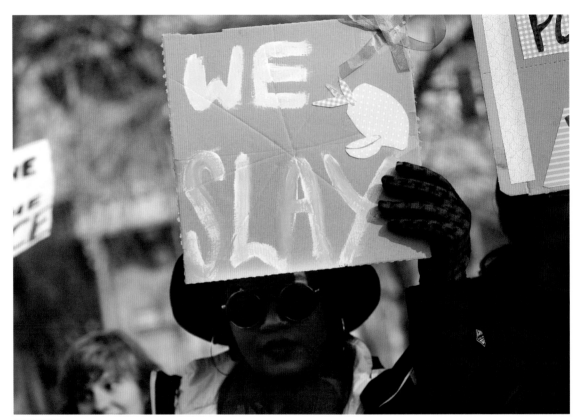

BUDAPEST

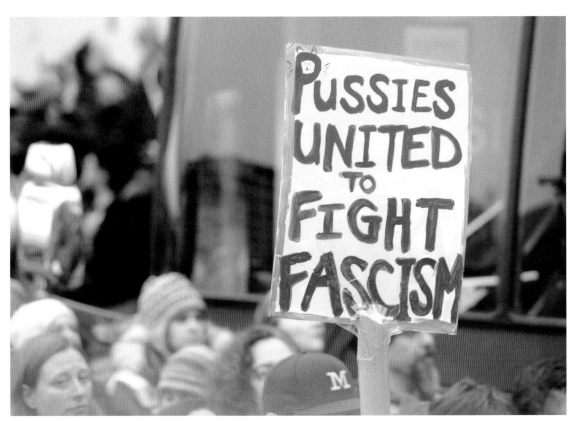

WASHINGTON, DC

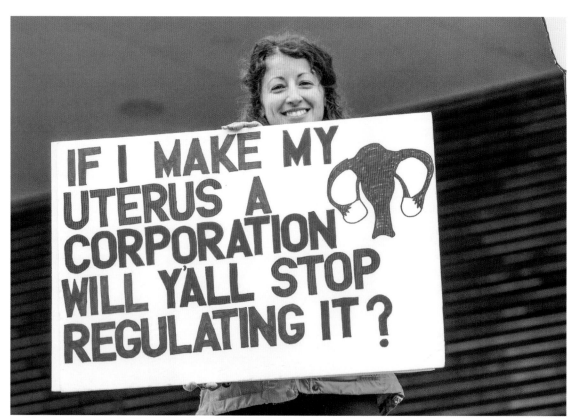

WASHINGTON, DC

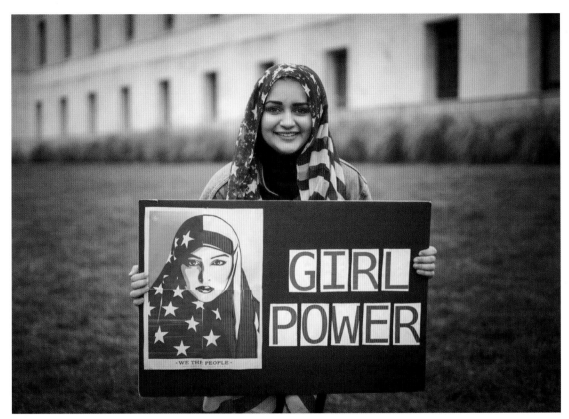

WASHINGTON, DC

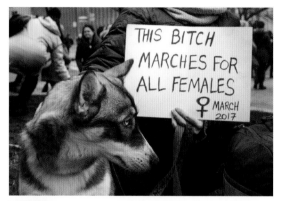

TORONTO

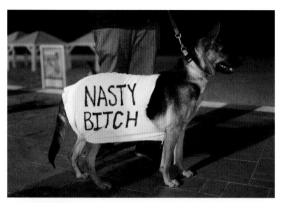

TEL AVIV-YAFO

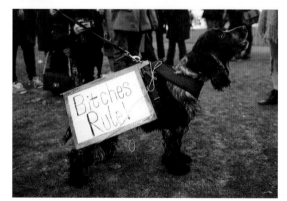

LONDON

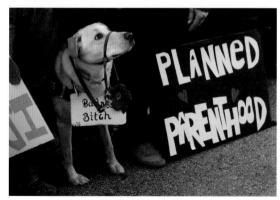

LOS ANGELES

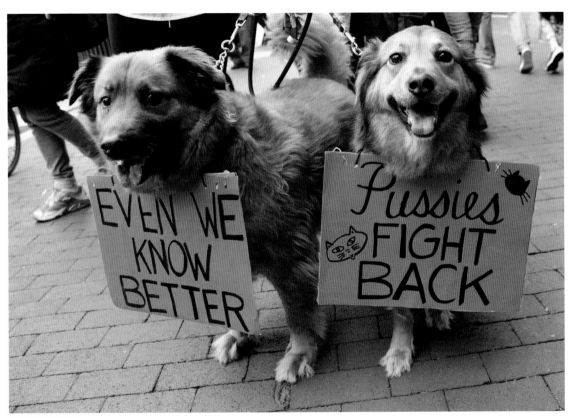

WASHINGTON, DC

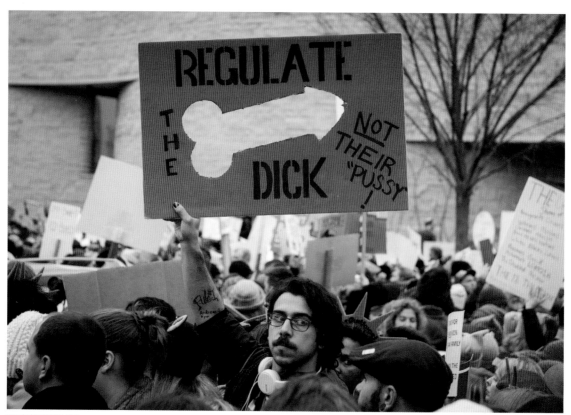

WASHINGTON, DC

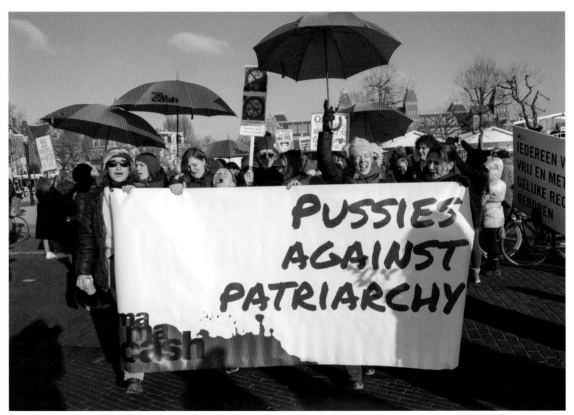

AMSTERDAM

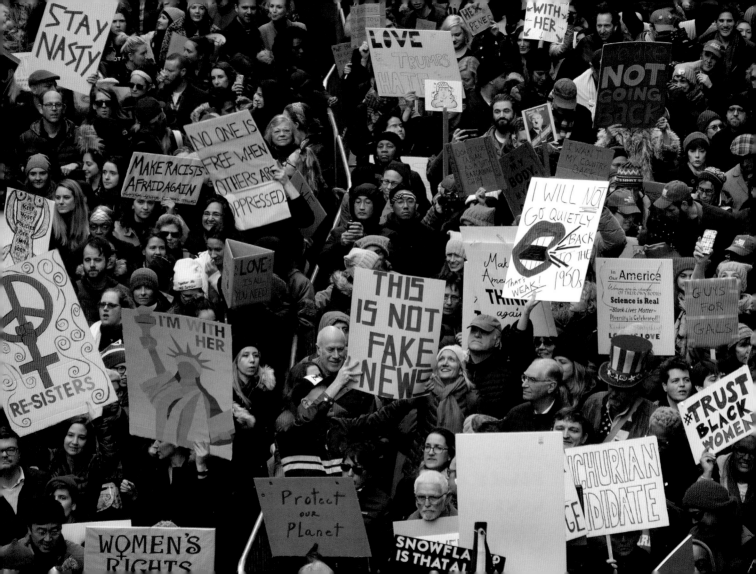

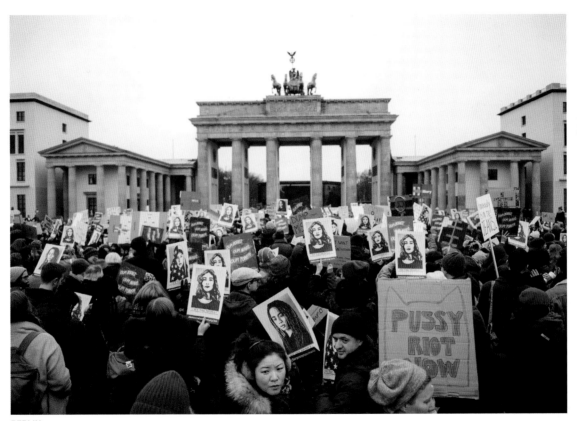

BERLIN
OPPOSITE: NEW YORK CITY

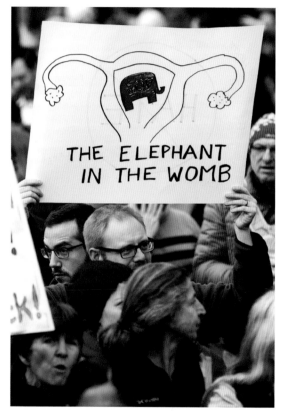

BOSTON

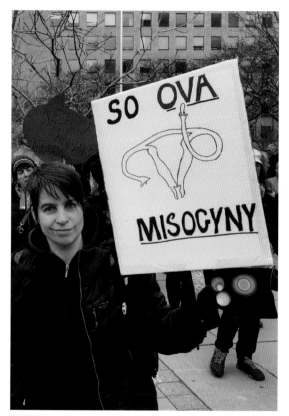

TORONTO

"When women organize, change happens. Women make the change."
—Helen Mirren

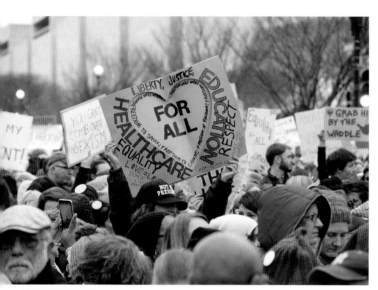

WASHINGTON, DC

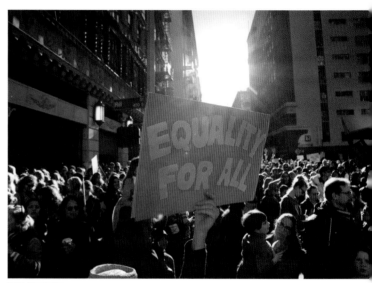

LOS ANGELES

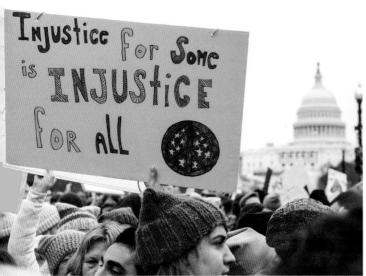

WASHINGTON, DC

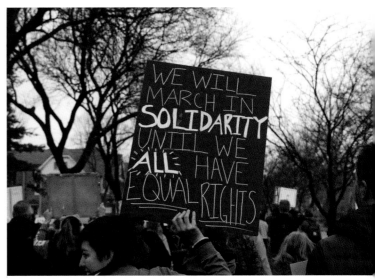

MILWAUKEE

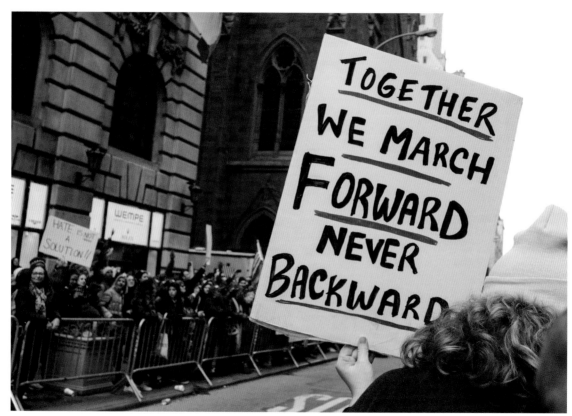

NEW YORK CITY

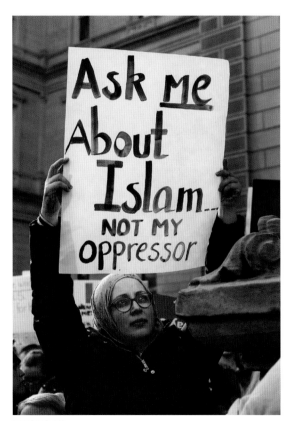

LANSING, MI

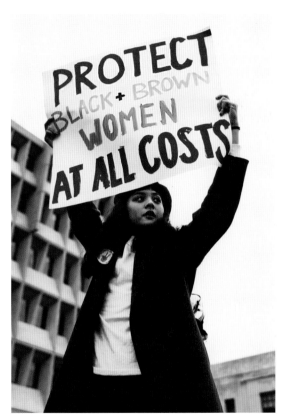

WASHINGTON, DC

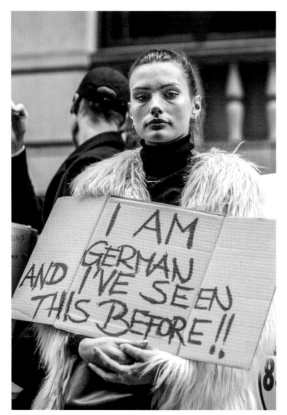

NEW YORK CITY

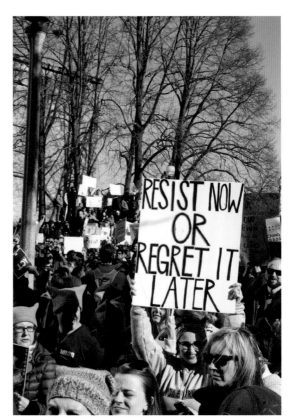

CHICAGO

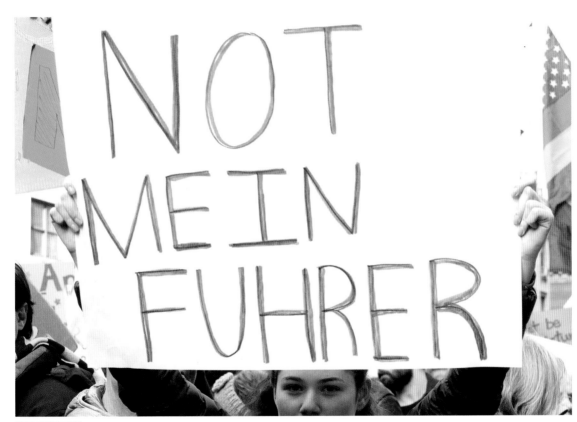

NEW YORK CITY

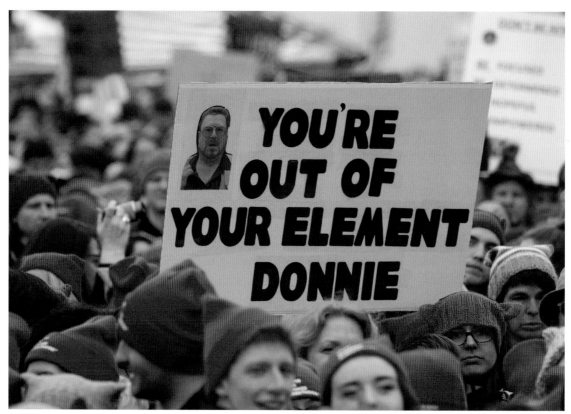

ABOVE AND OPPOSITE: WASHINGTON, DC

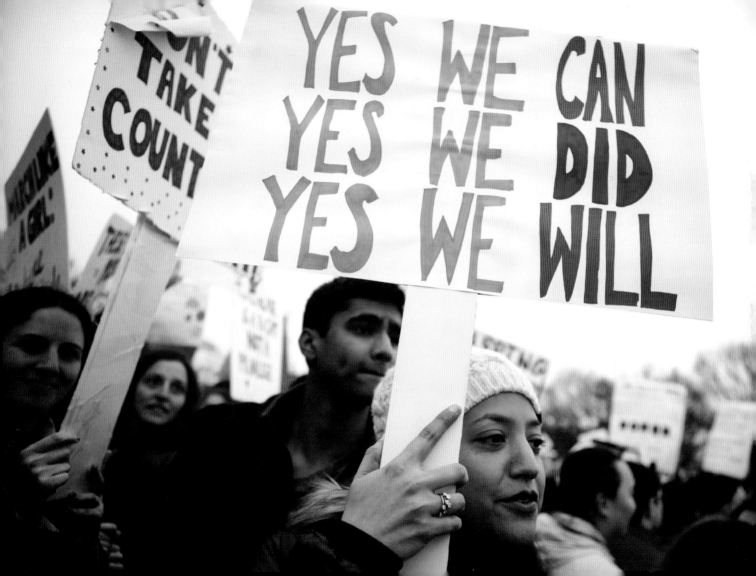

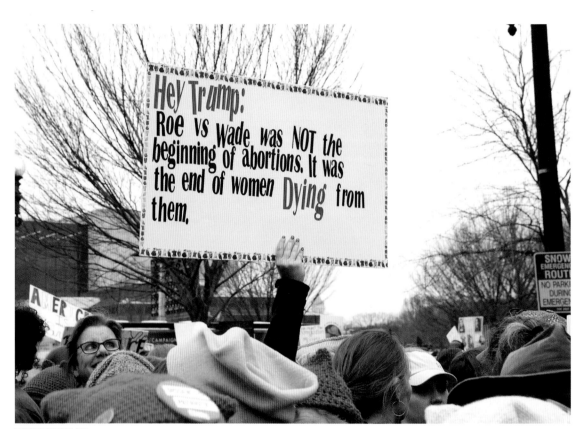

WASHINGTON, DC

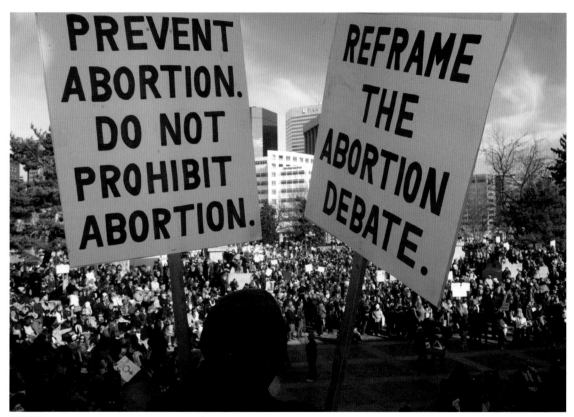

DENVER

"We can't give up. Today is the beginning of a new movement to hold power accountable to truth."
—Barbra Streisand

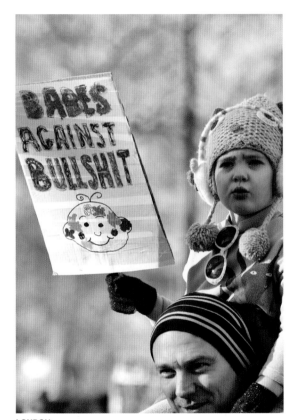

LONDON

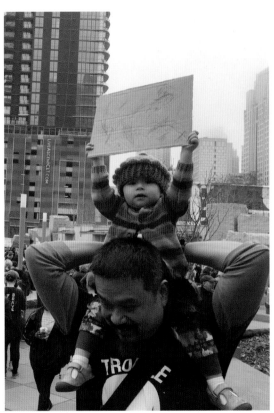

CHARLOTTE, NC

NEW YORK CITY

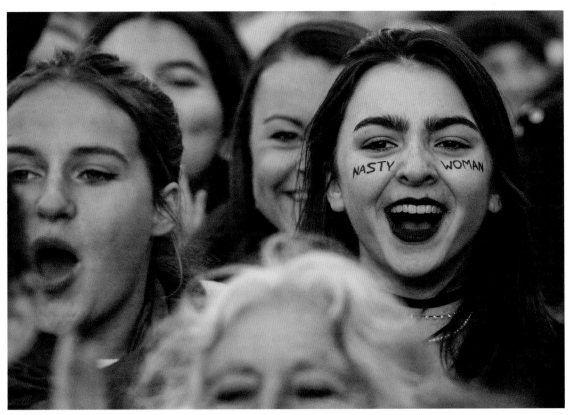

LONDON

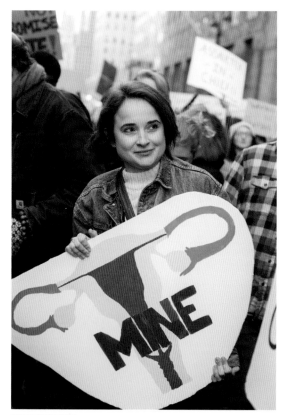

NEW YORK CITY

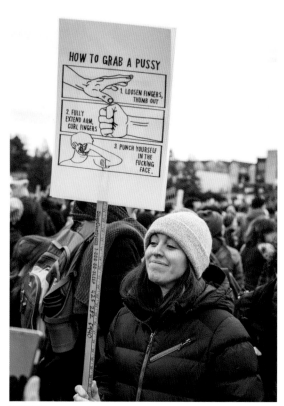

SEATTLE

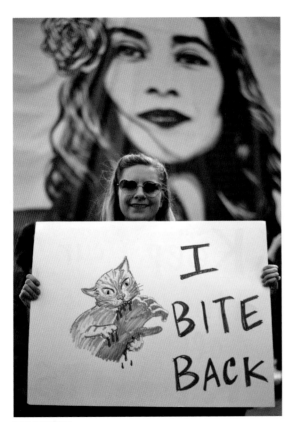

LOS ANGELES

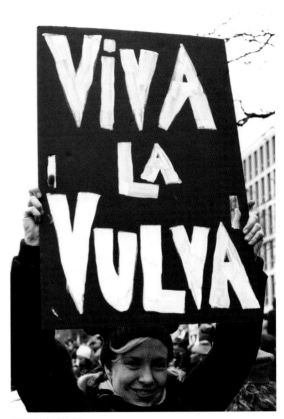

WASHINGTON, DC

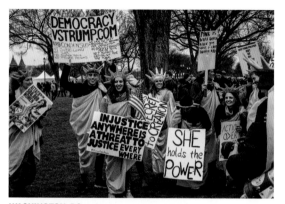

WASHINGTON, DC

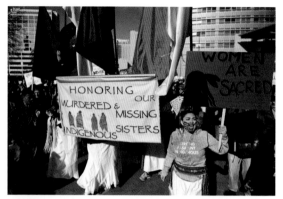

DENVER

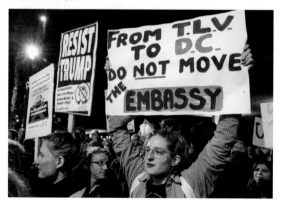

TEL AVIV-YAFO

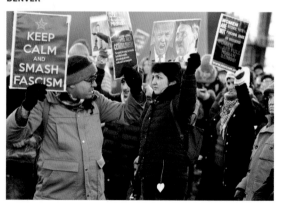

HELSINKI

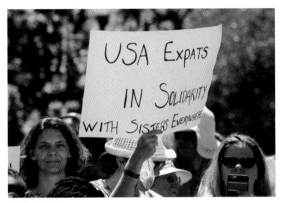

CAPE TOWN

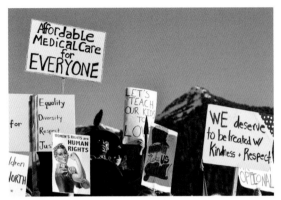

KETCHIKAN

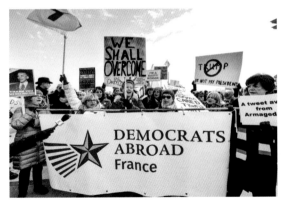

PARIS

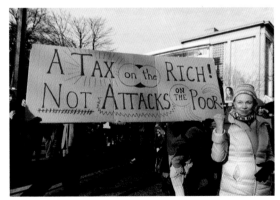

PARIS

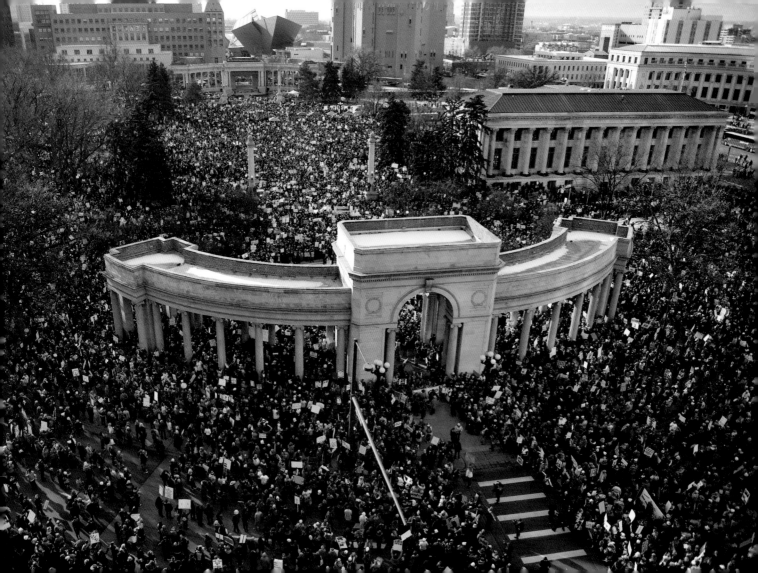

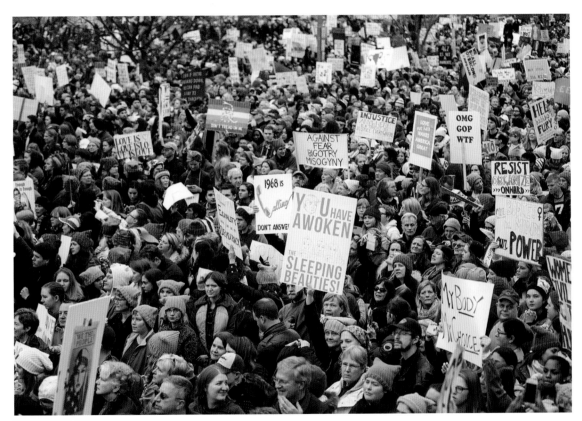

WASHINGTON, DC
OPPOSITE: DENVER

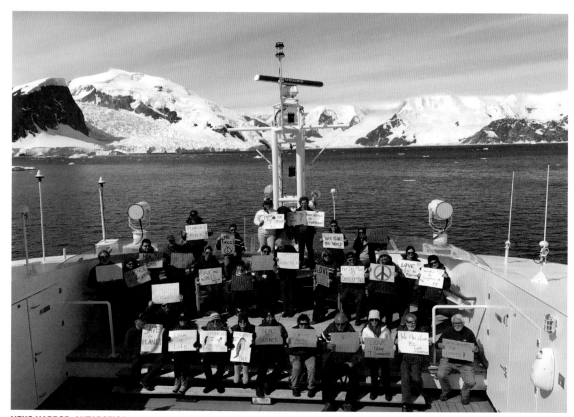

NEKO HARBOR, ANTARCTICA

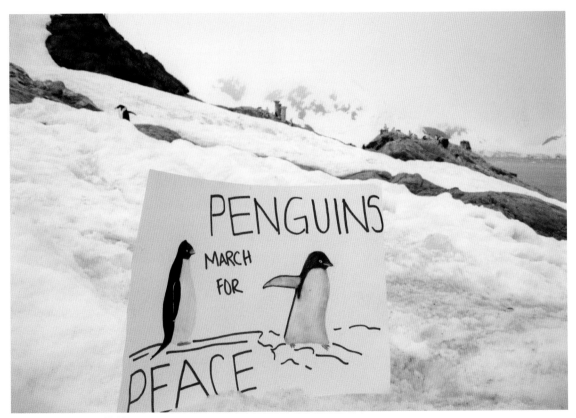

PARADISE BAY, ANTARCTICA

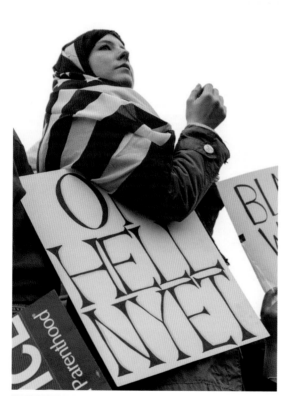

WASHINGTON, DC

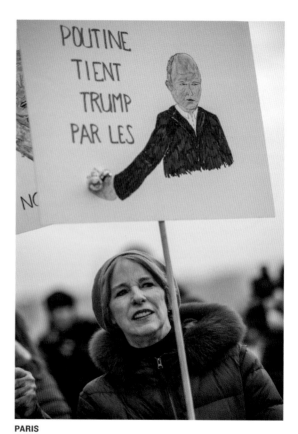

PARIS

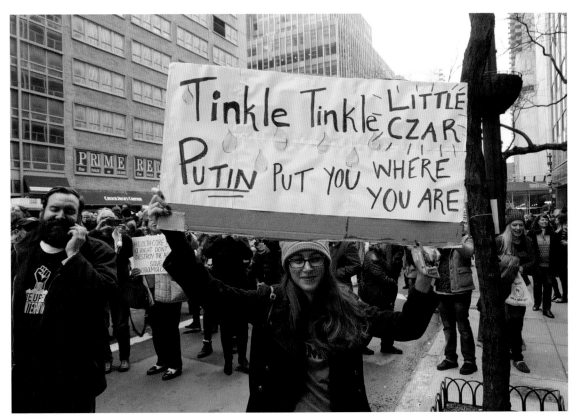

NEW YORK CITY

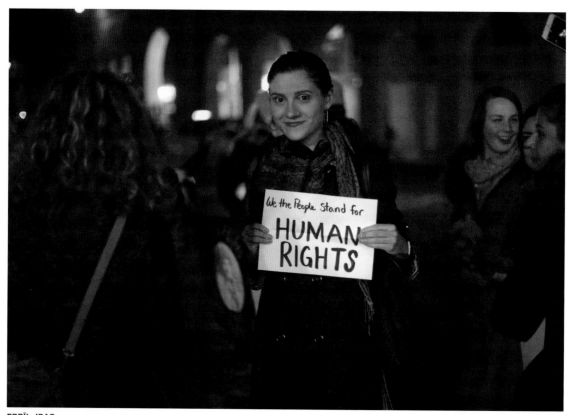

ERBĪL, IRAQ
OPPOSITE: NEW YORK CITY

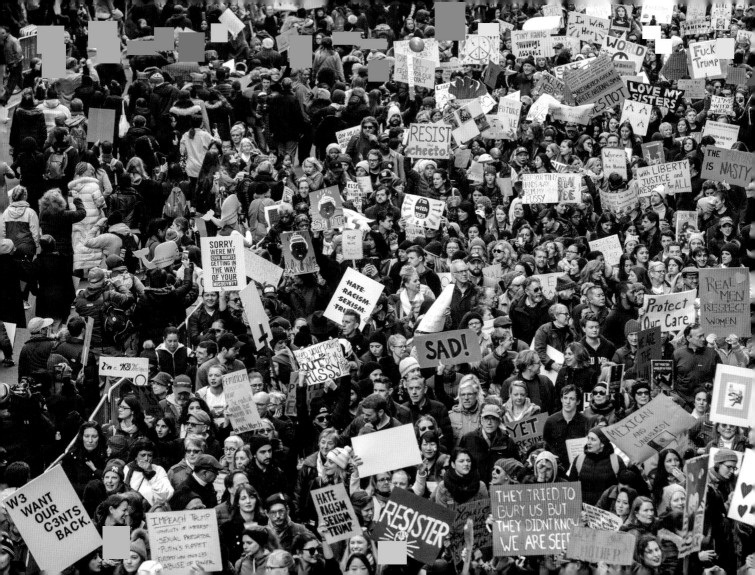

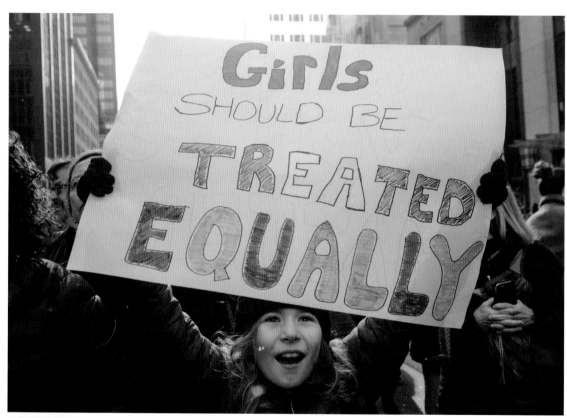

NEW YORK CITY

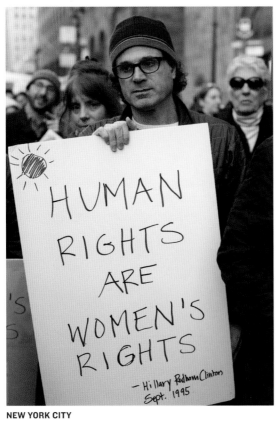

NEW YORK CITY

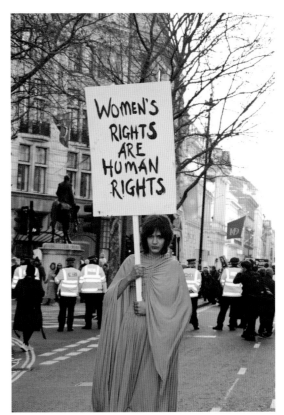

LONDON

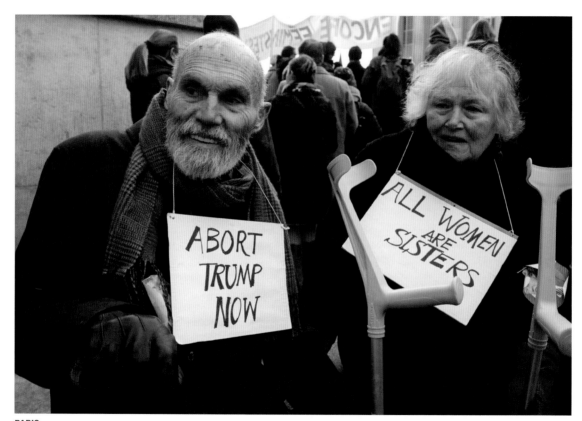

PARIS

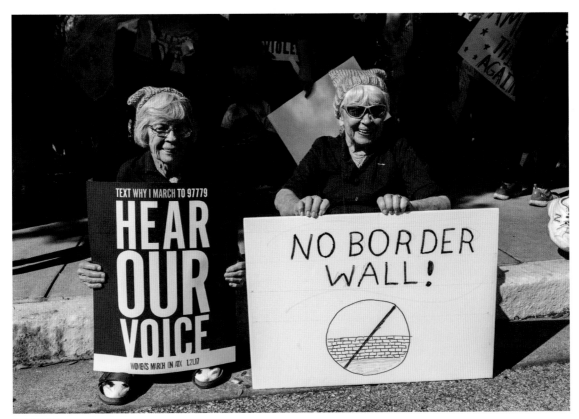

AUSTIN, TX

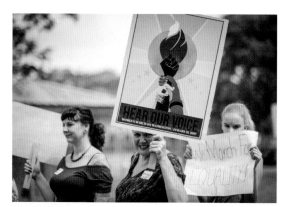

ACCRA, GHANA

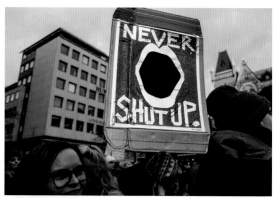

STOCKHOLM

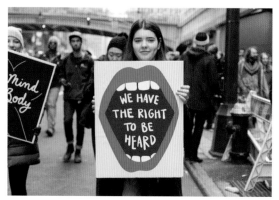

NEW YORK CITY

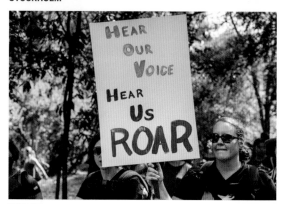

NAIROBI

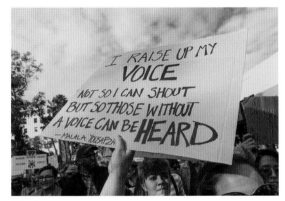

SANTA BARBARA

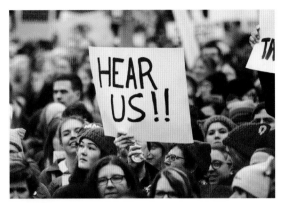

WASHINGTON, DC

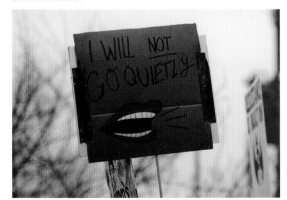

PORTLAND, OR

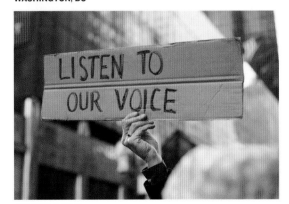

NEW YORK CITY

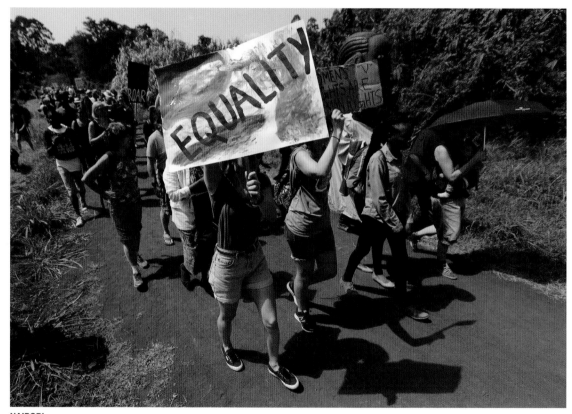

NAIROBI

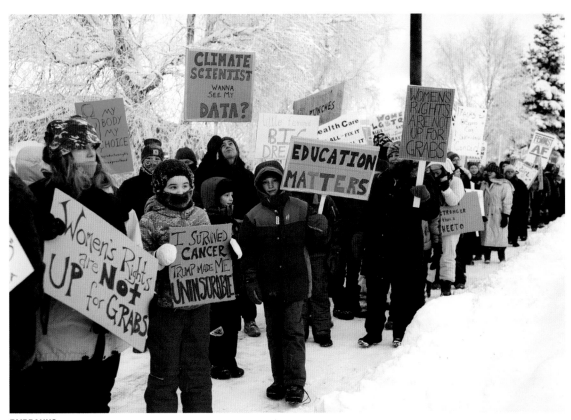

FAIRBANKS

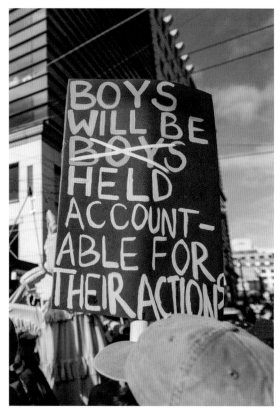

SEATTLE

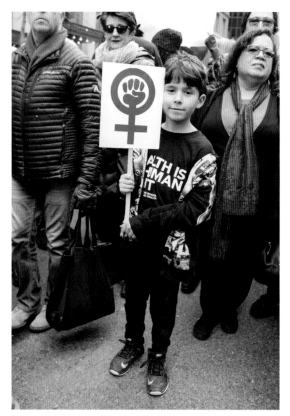

NEW YORK CITY

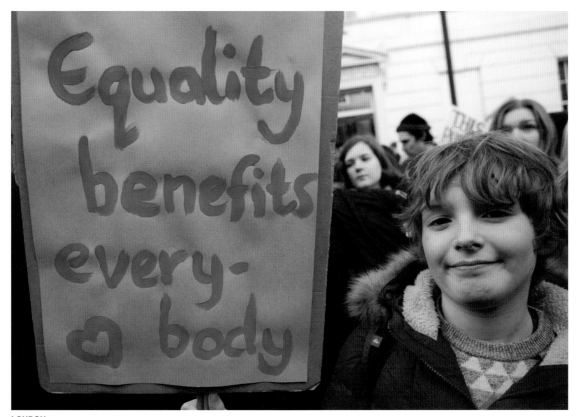

LONDON

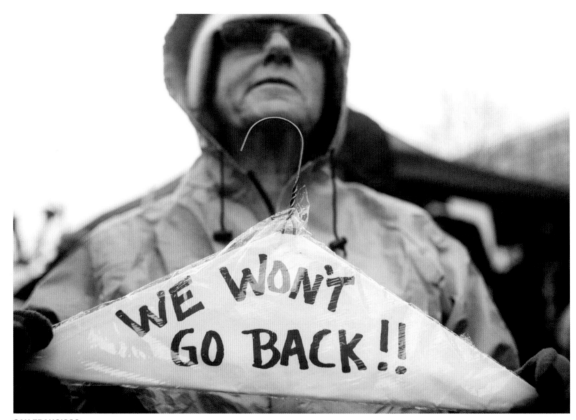

SAN FRANCISCO

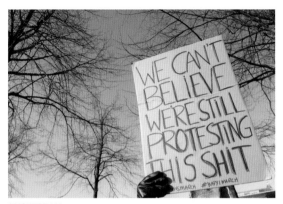

AMSTERDAM

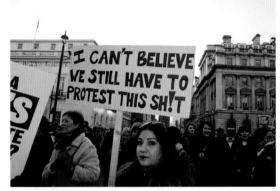

LONDON

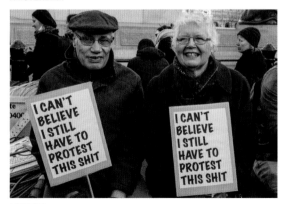

LONDON

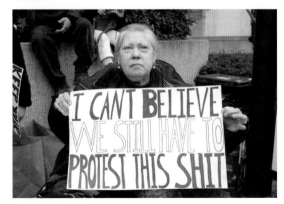

WASHINGTON, DC

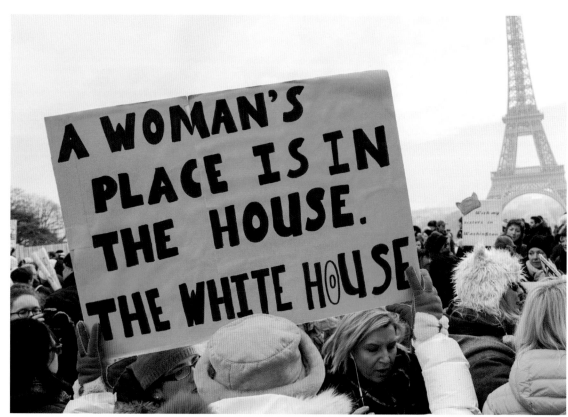

PARIS
OPPOSITE: WASHINGTON, DC

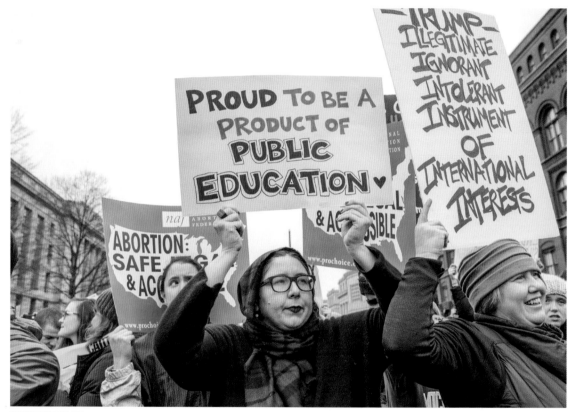

WASHINGTON, DC

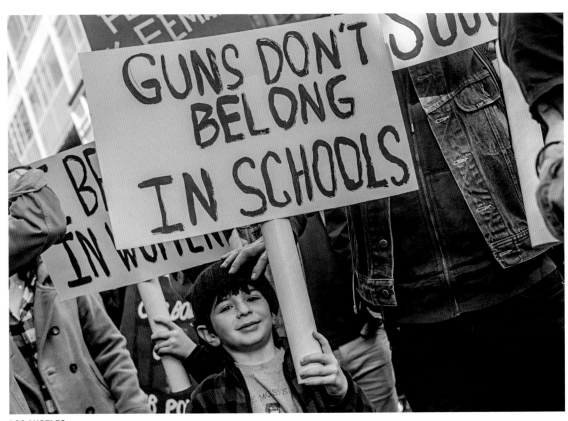

LOS ANGELES

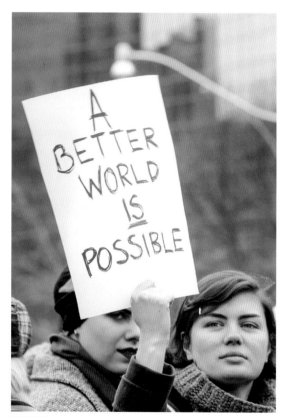

TORONTO

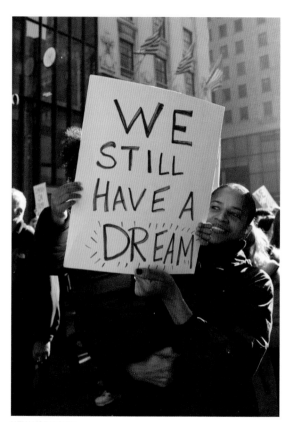

NEW YORK CITY

"We will not retreat when being attacked. We will stand up and we will fight."
—Senator Kamala Harris

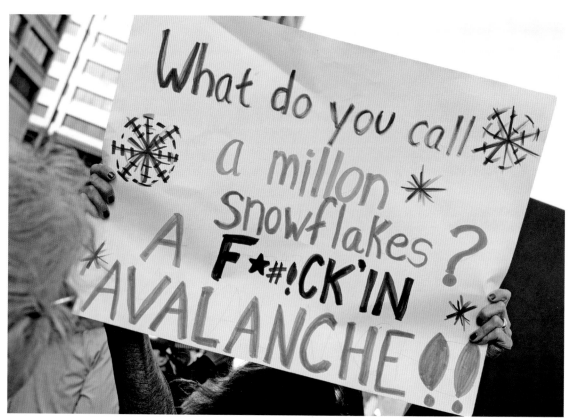

CLEVELAND, OH
OPPOSITE: PHILADELPHIA

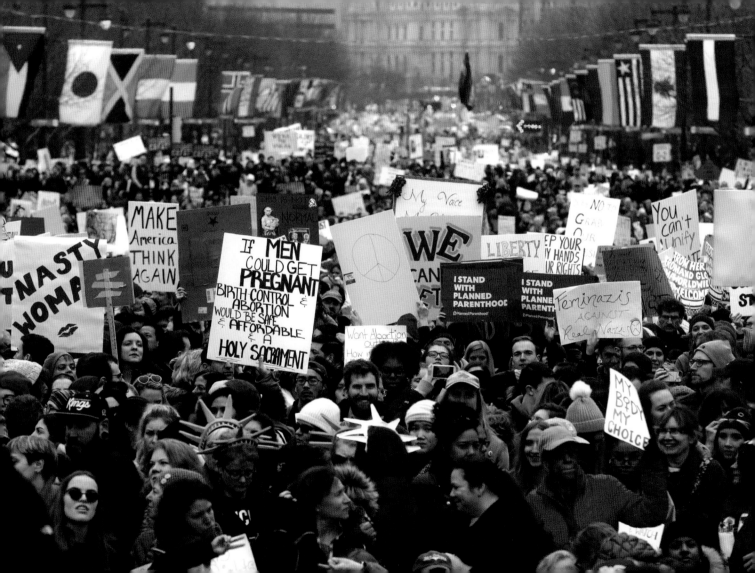

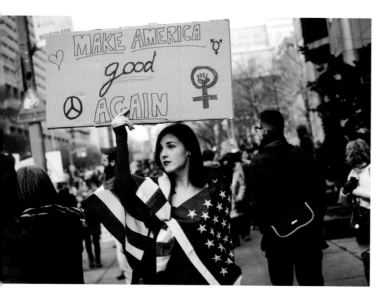

TORONTO

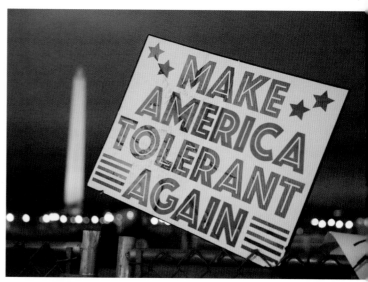

WASHINGTON, DC

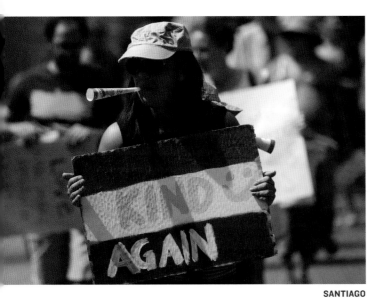

SANTIAGO

SEATTLE

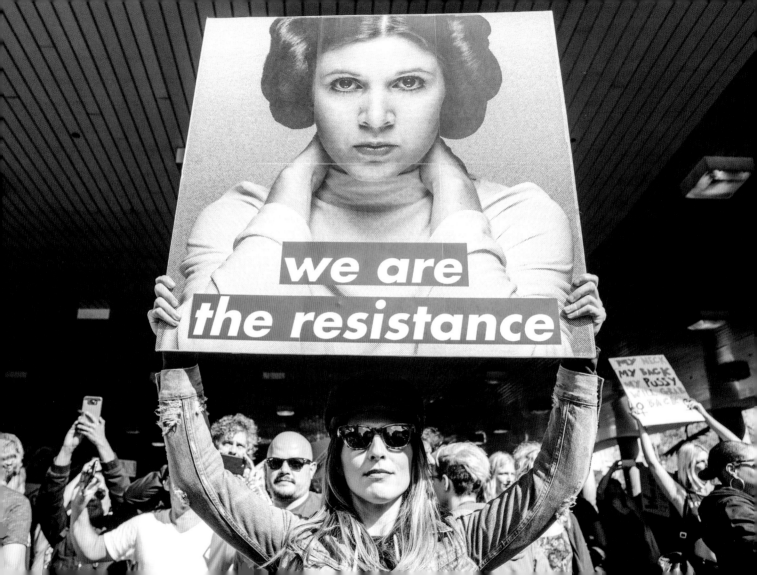

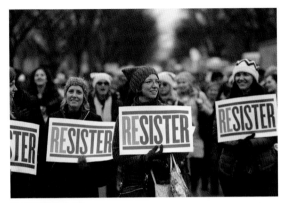

WASHINGTON, DC

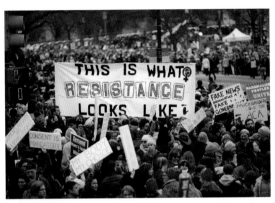

WASHINGTON, DC

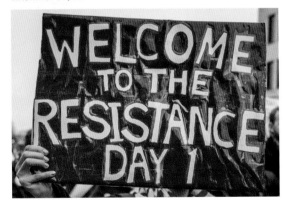

WASHINGTON, DC
OPPOSITE: LOS ANGELES

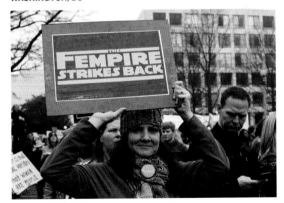

WASHINGTON, DC

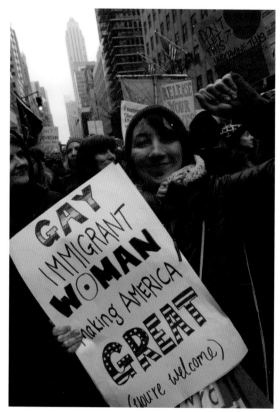

NEW YORK CITY

WASHINGTON, DC

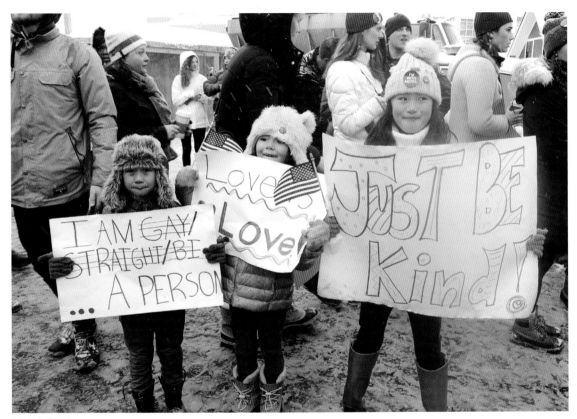

PARK CITY, UT

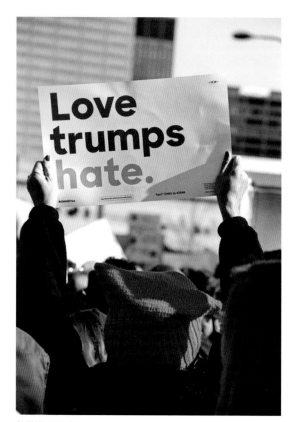

CLEVELAND, OH

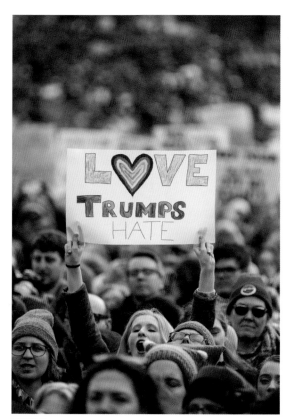

BOSTON

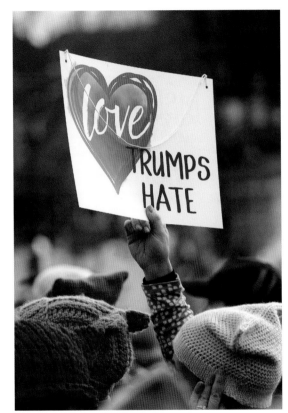

SEATTLE

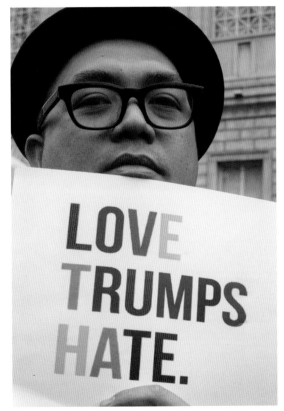

SAN FRANCISCO

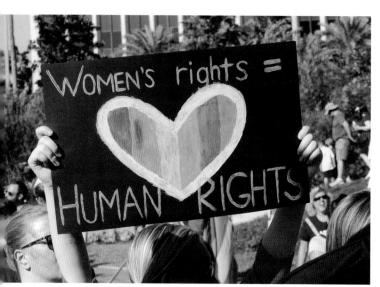

ORLANDO

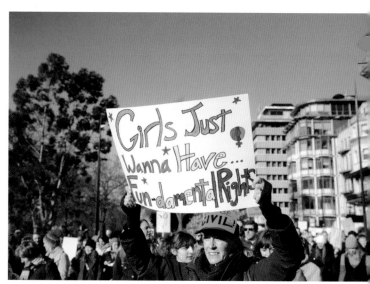

LONDON

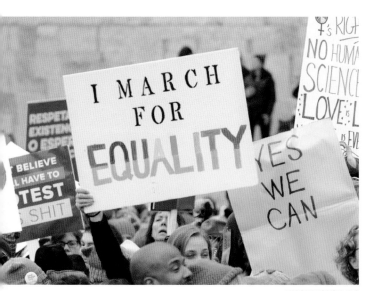

WASHINGTON, DC

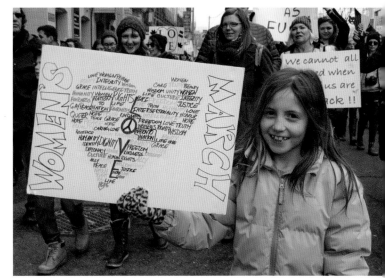

TORONTO

"Continue to embrace the things that make you unique even if it makes others uncomfortable."
—Janelle Monáe

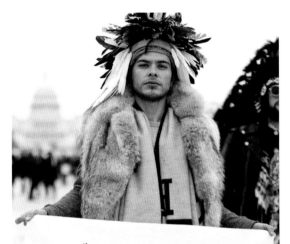

"All young people, regardless of sexual orientation or identity, deserve a safe and supportive environment in which to achieve their full potential."

– Harvey milk –

WASHINGTON, DC

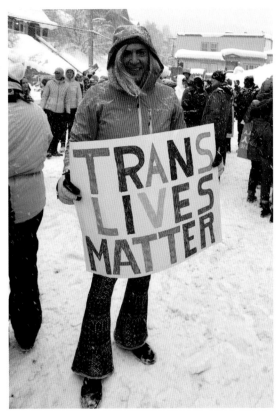

TRANS LIVES MATTER

PARK CITY, UT

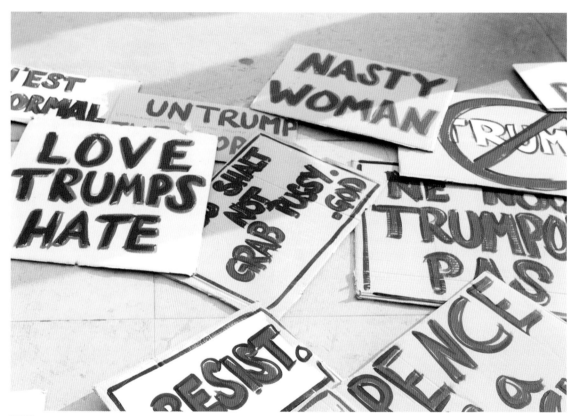

PARIS

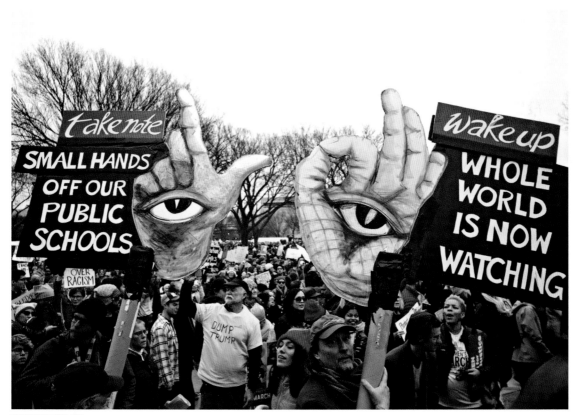

WASHINGTON, DC

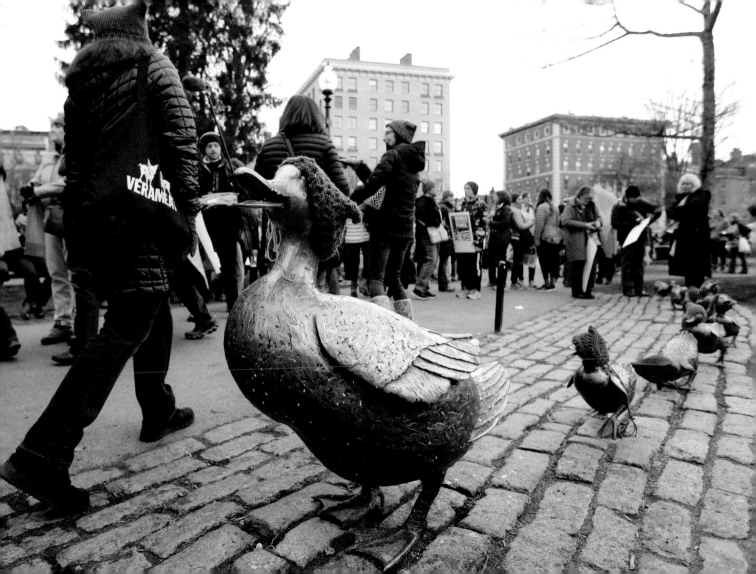

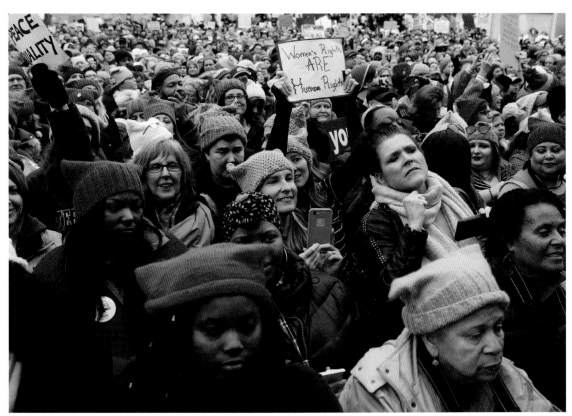

WASHINGTON, DC
OPPOSITE: BOSTON

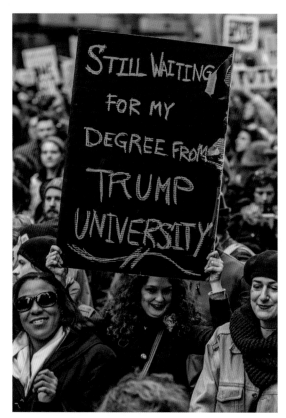

NEW YORK CITY

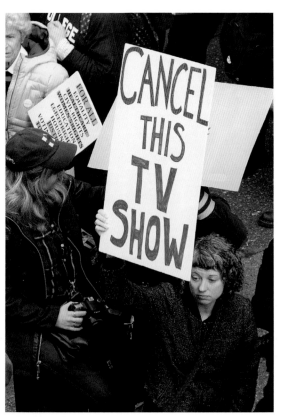

NEW YORK CITY

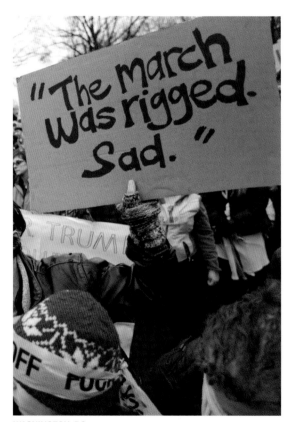

WASHINGTON, DC

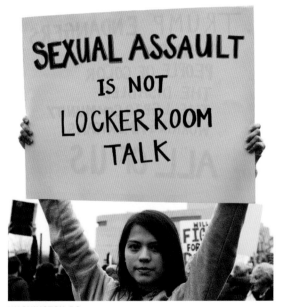

WASHINGTON, DC

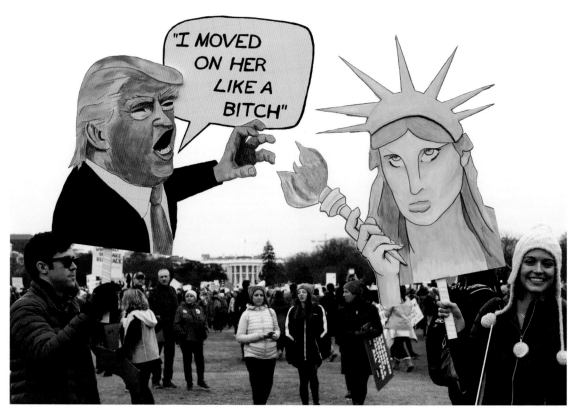

WASHINGTON, DC

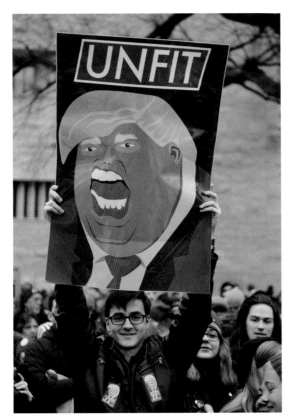

WASHINGTON, DC

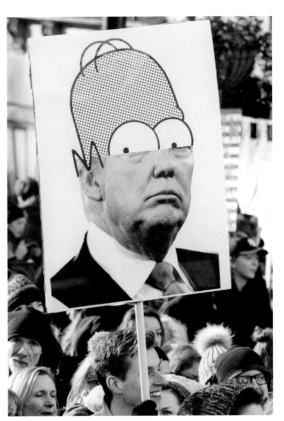

LONDON

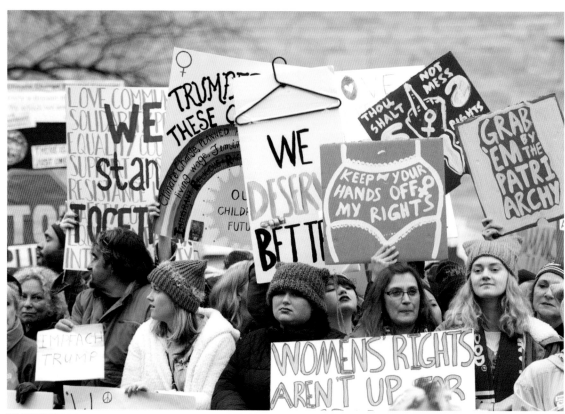

WASHINGTON, DC
OPPOSITE: NEW YORK CITY

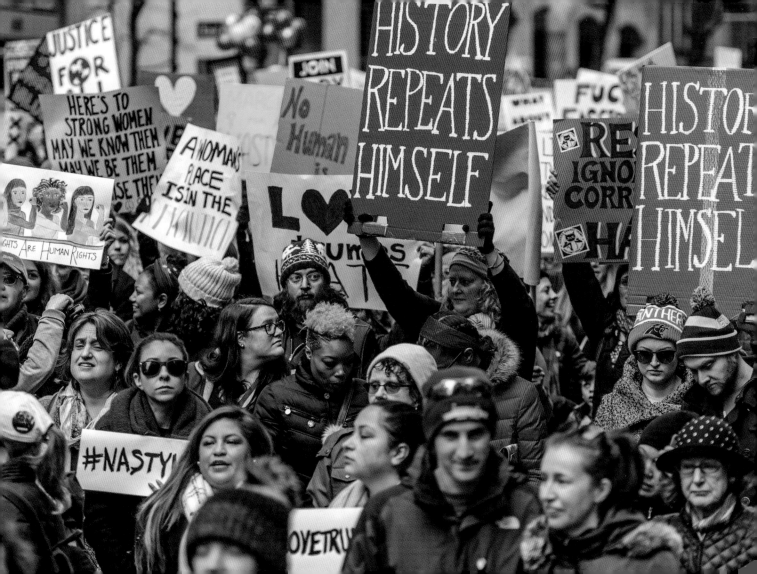

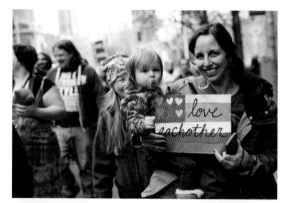

SEATTLE

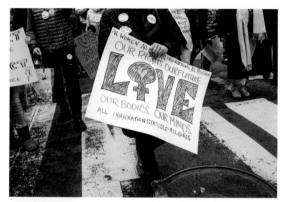

NEW YORK CITY

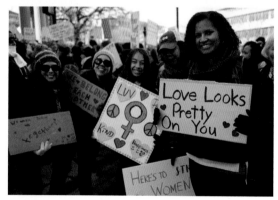

DENVER

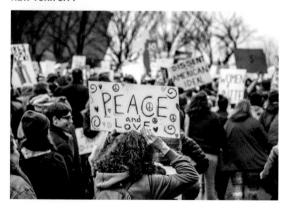

WASHINGTON, DC

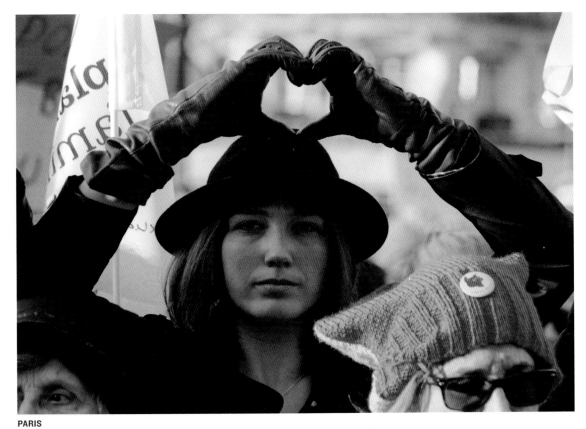

PARIS

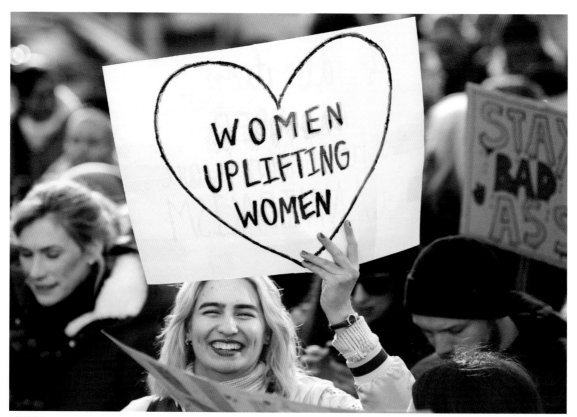

LONDON

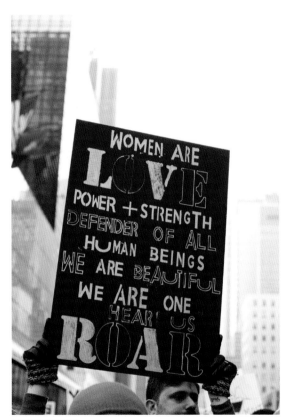

NEW YORK CITY

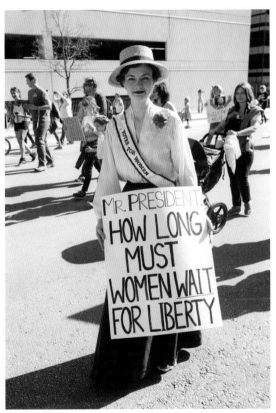

AUSTIN, TX

"I am not as nasty as racism, fraud, conflict of interest, homophobia, sexual assault, transphobia, white supremacy, misogyny, ignorance, white privilege."
—Ashley Judd,
quoting Nina Donovan

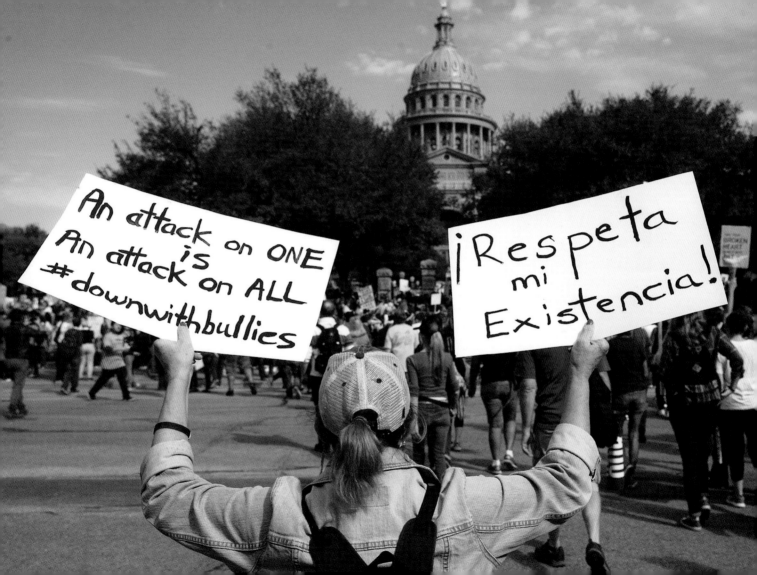

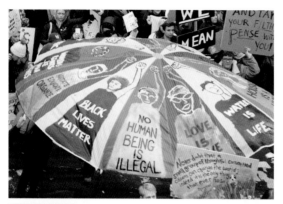

NEW YORK CITY

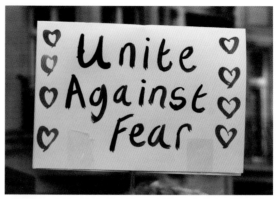

LONDON

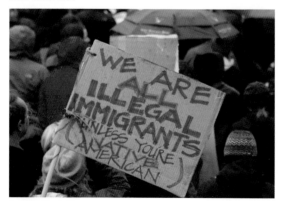

SAN FRANCISCO
PRECEDING: AUSTIN, TX

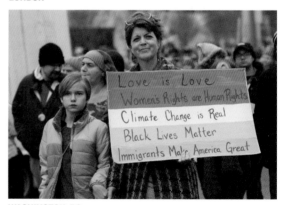

WASHINGTON, DC

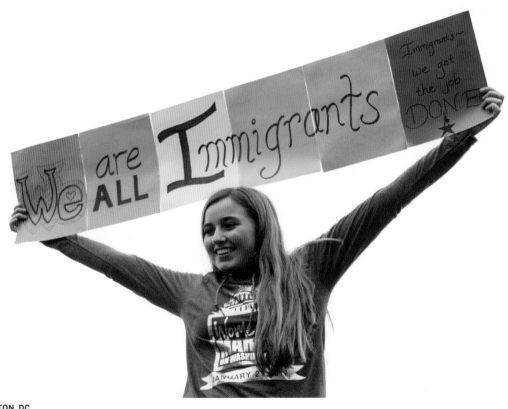

WASHINGTON, DC

185

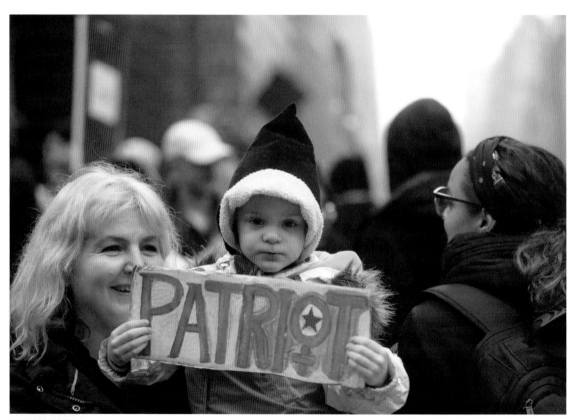

NEW YORK CITY
OPPOSITE: WASHINGTON, DC

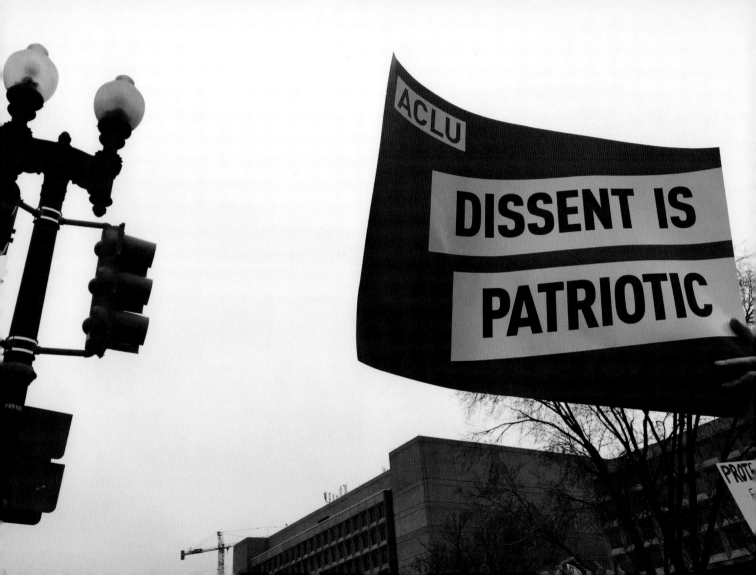

LONDON

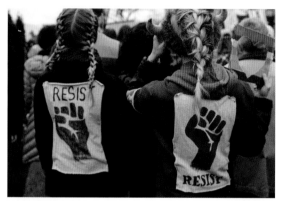

WASHINGTON, DC

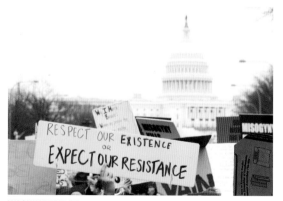

WASHINGTON, DC

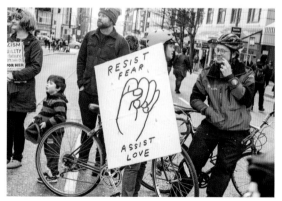

SEATTLE

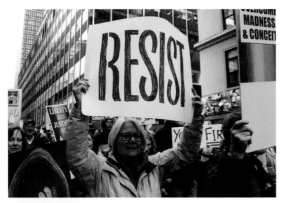

NEW YORK CITY

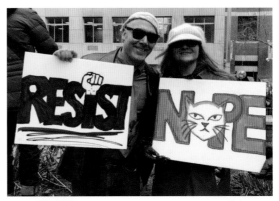

NEW YORK CITY

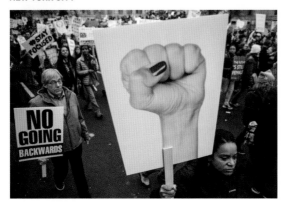

WASHINGTON, DC

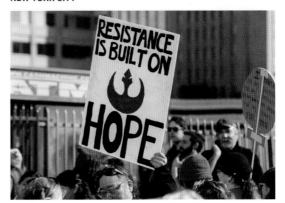

LOS ANGELES

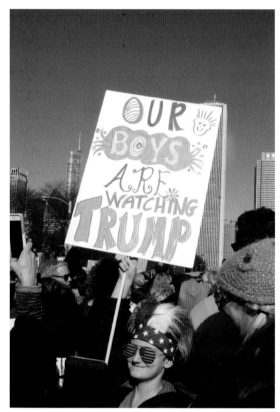

CHICAGO

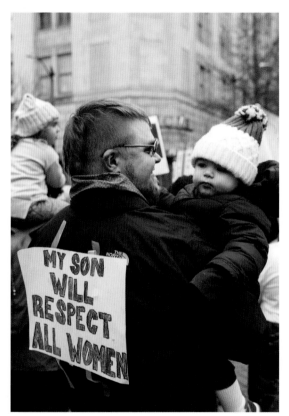

SEATTLE

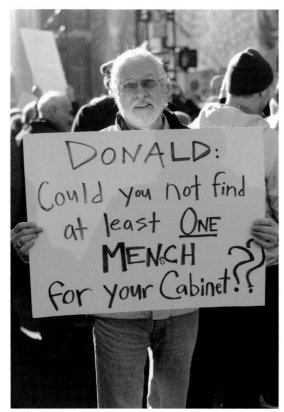

NEW YORK CITY

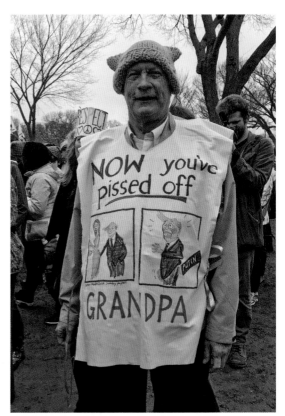

WASHINGTON, DC

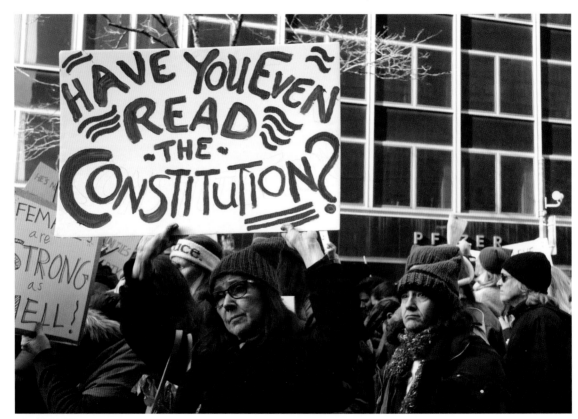

NEW YORK CITY
OPPOSITE: WASHINGTON, DC

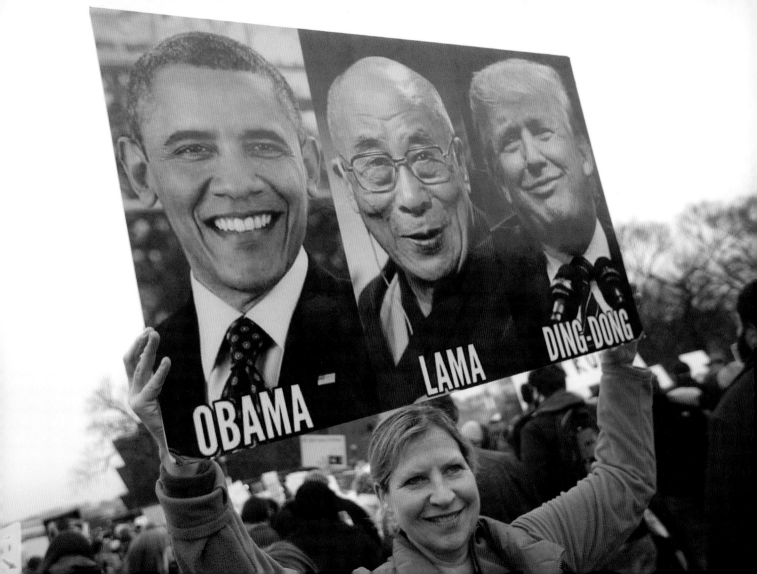

OBAMA LAMA DING-DONG

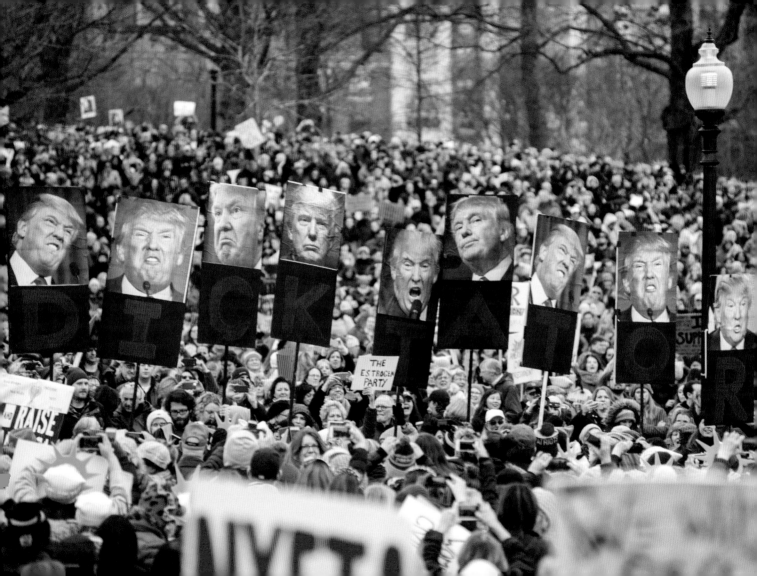

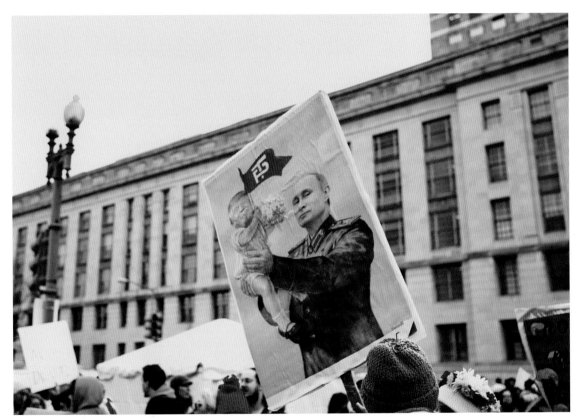

WASHINGTON, DC
OPPOSITE: BOSTON

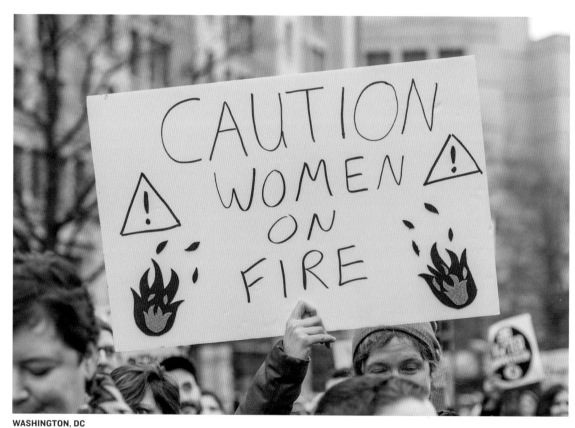

WASHINGTON, DC

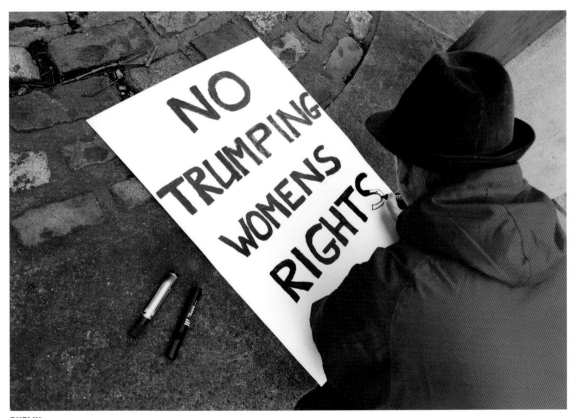

DUBLIN

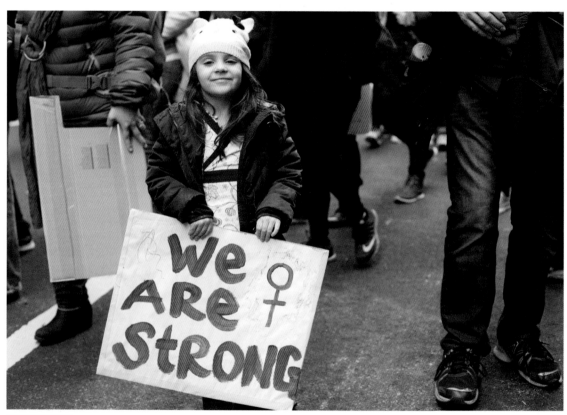

NEW YORK CITY
OPPOSITE: PRAGUE

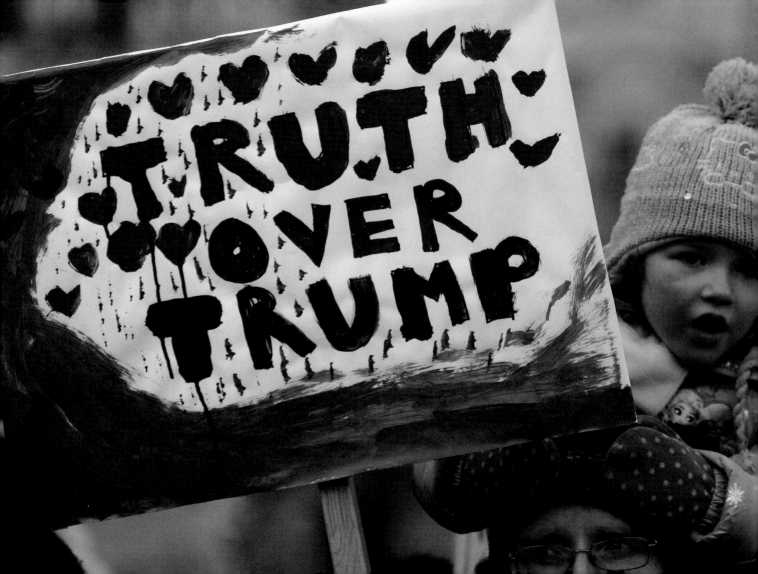

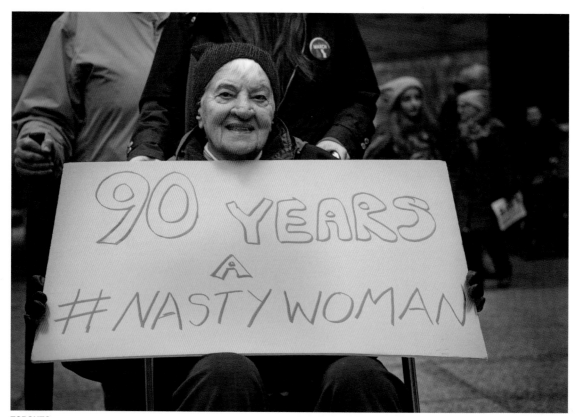

TORONTO

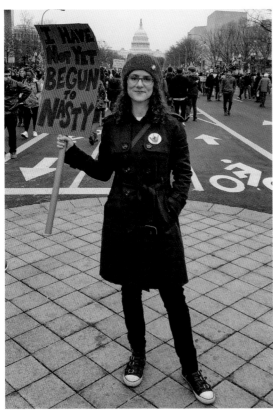

WASHINGTON, DC

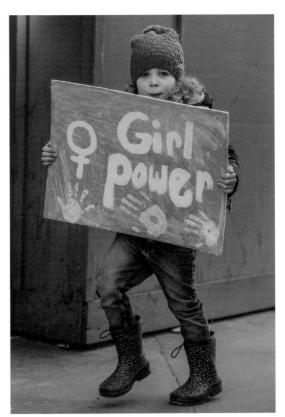

LONDON

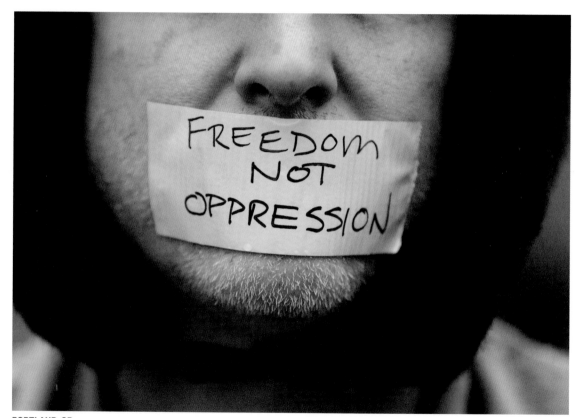

PORTLAND, OR

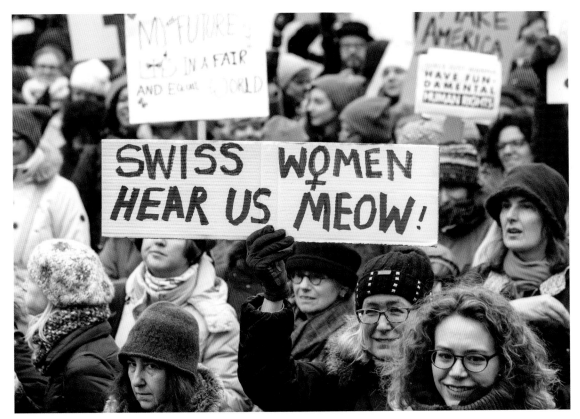

GENEVA

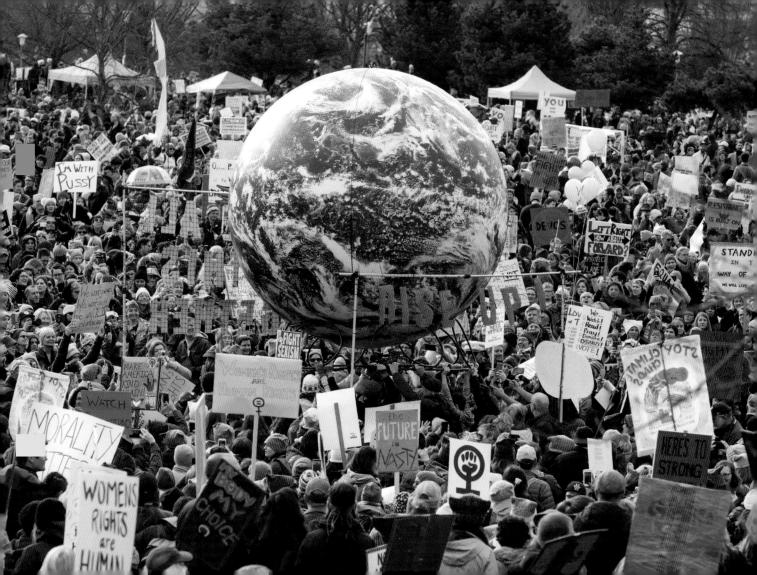

"So this is what we gotta do: Don't get frustrated, get involved. Don't complain, organize."
—Maryum Ali

SEATTLE

WASHINGTON, DC

WASHINGTON, DC
PRECEDING: SEATTLE

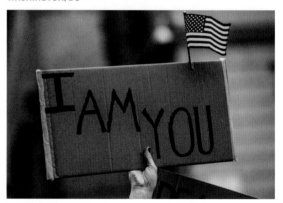

BARCELONA

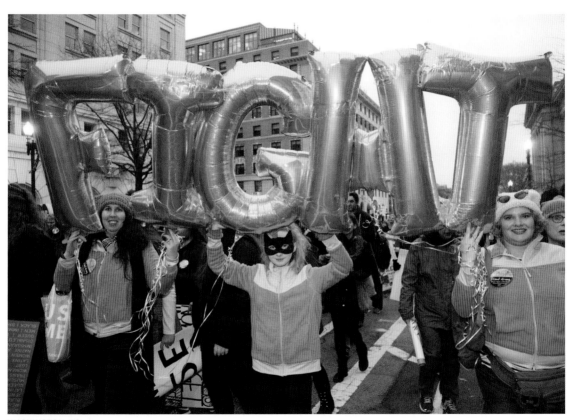

WASHINGTON, DC

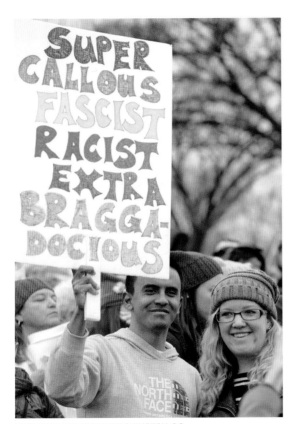

OPPOSITE AND ABOVE: WASHINGTON, DC

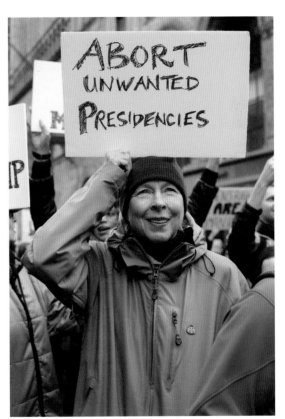

NEW YORK CITY

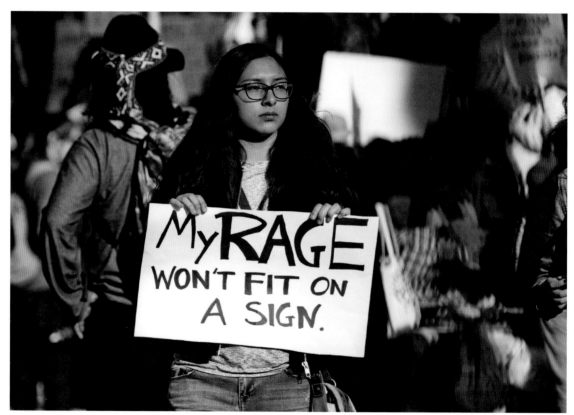

LOS ANGELES

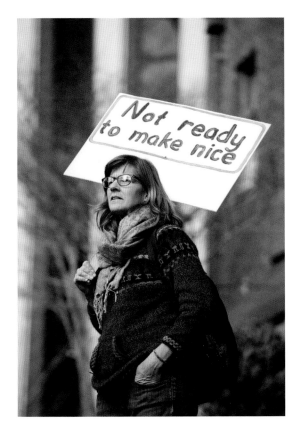

SEATTLE

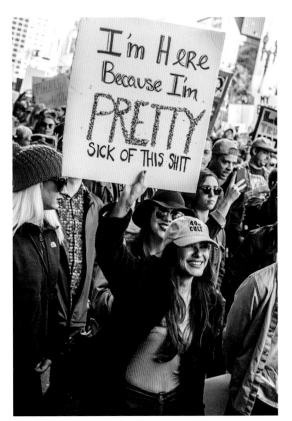

LOS ANGELES

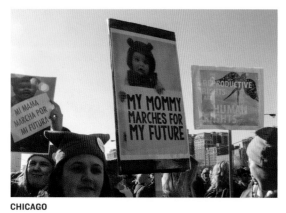

CHICAGO

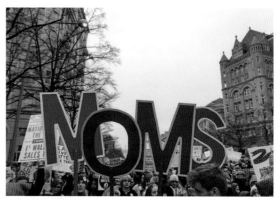

WASHINGTON, DC

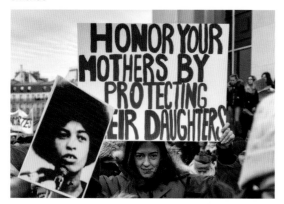

PARIS

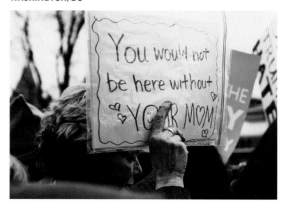

WASHINGTON, DC

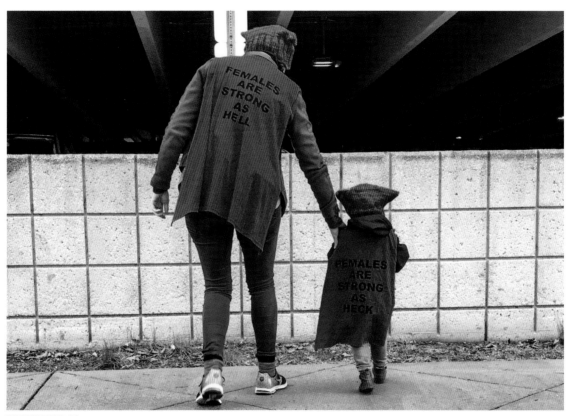

WASHINGTON, DC

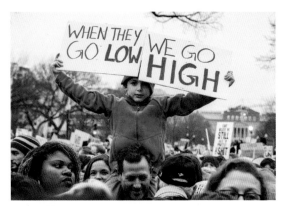

WASHINGTON, DC

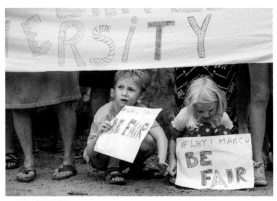

ACCRA, GHANA

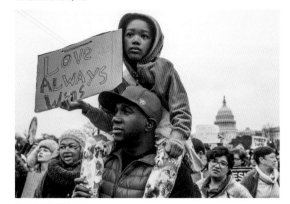

WASHINGTON, DC

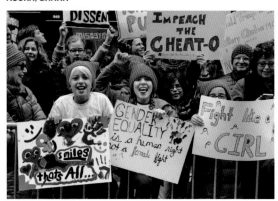

NEW YORK CITY

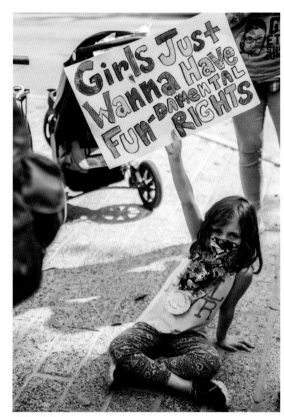

AUSTIN, TX

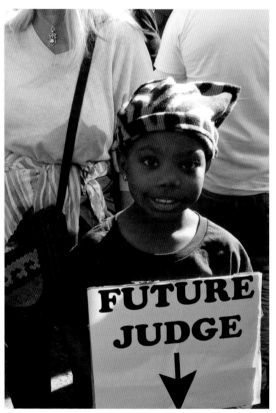

LOS ANGELES

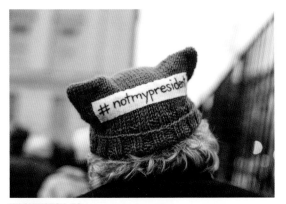

WASHINGTON, DC

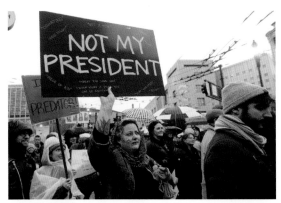

SAN FRANCISCO

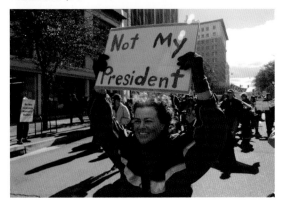

TUCSON

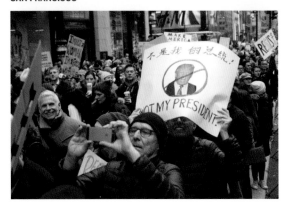

NEW YORK CITY

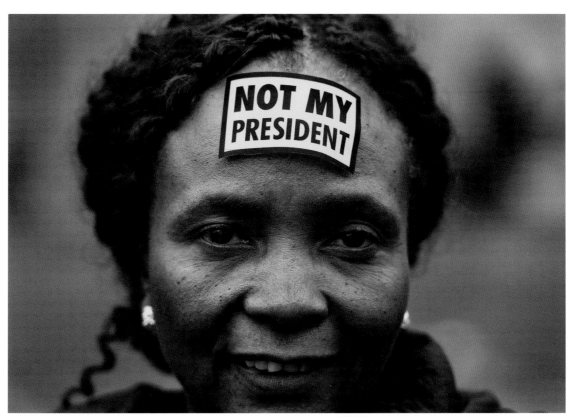

WASHINGTON, DC

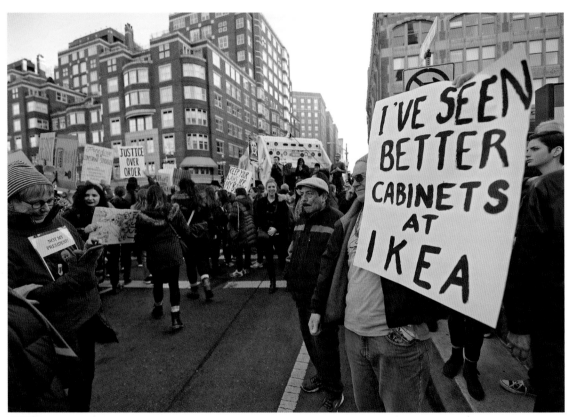

BOSTON
OPPOSITE: NEW YORK CITY

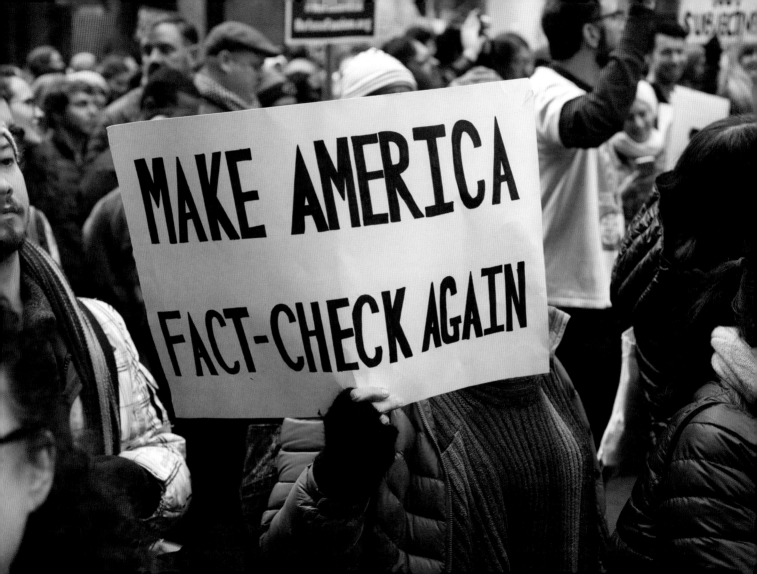

"We don't want to legitimize the ideas of bigotry or misogyny. We want to make sure they don't become normalized. That's what we're fighting for."
—Ayebatonye Abrakasa, Women's March co-organizer

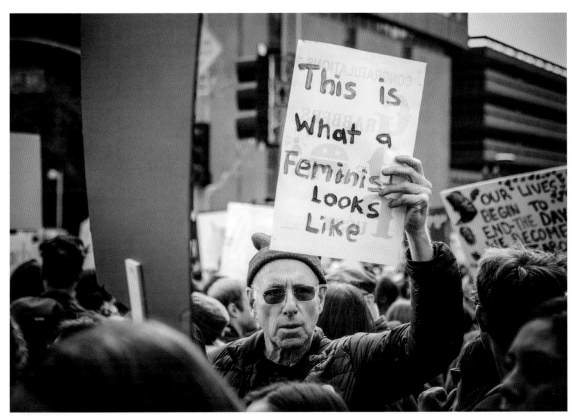

LOS ANGELES

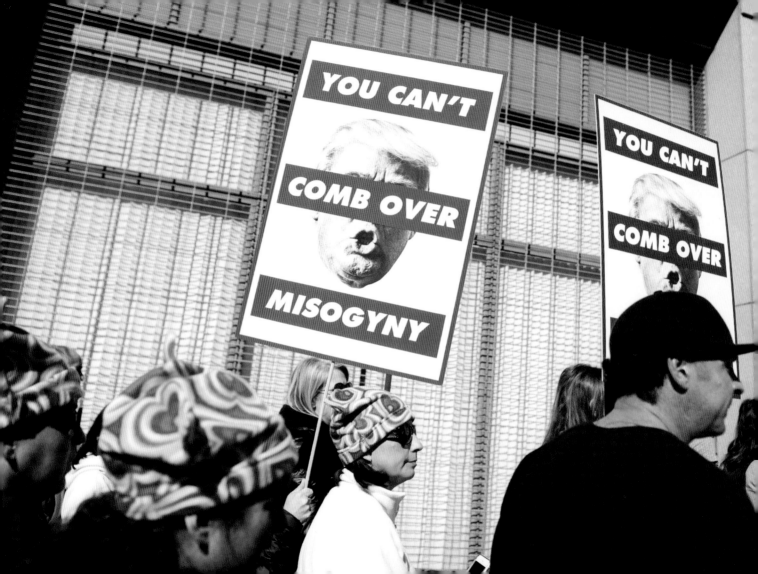

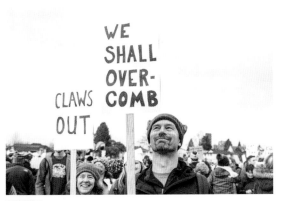

SEATTLE

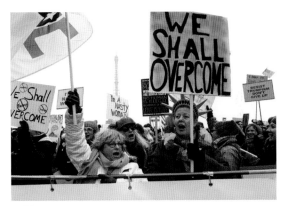

PARIS

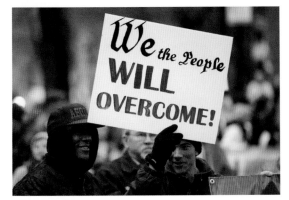

PORTLAND, OR
OPPOSITE: LOS ANGELES

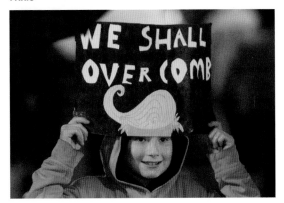

SAN FRANCISCO

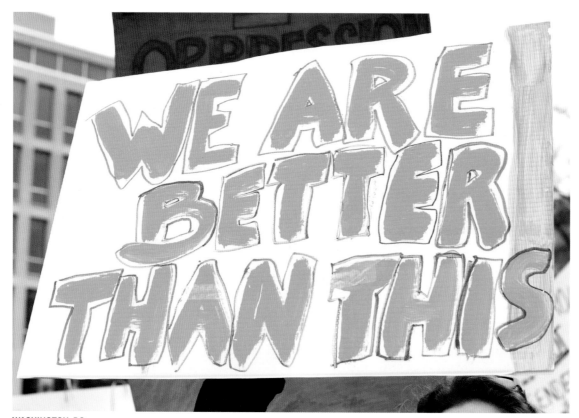

WASHINGTON, DC

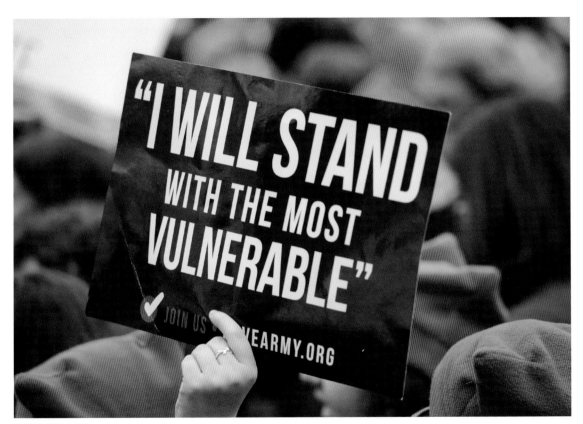

WASHINGTON, DC

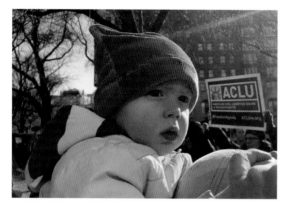

BOSTON

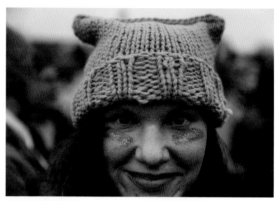

WASHINGTON, DC

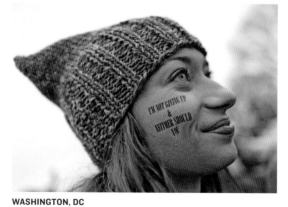

WASHINGTON, DC

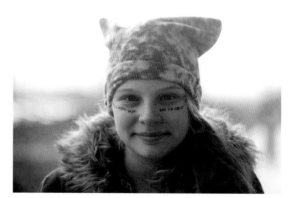

BOSTON

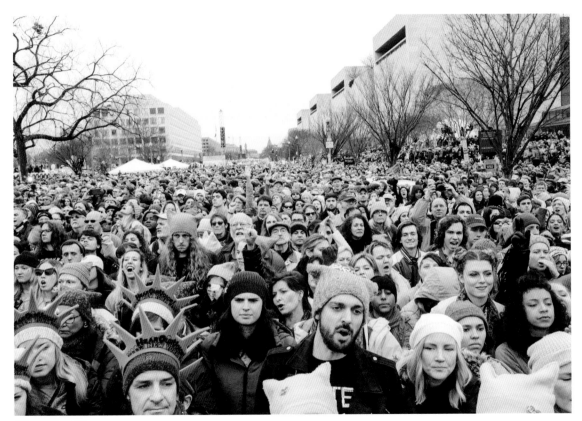

WASHINGTON, DC

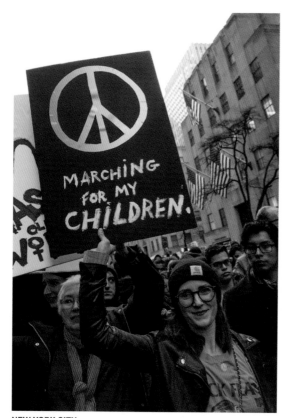

NEW YORK CITY

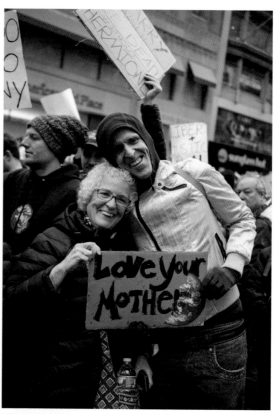

NEW YORK CITY
OPPOSITE: PARIS

228

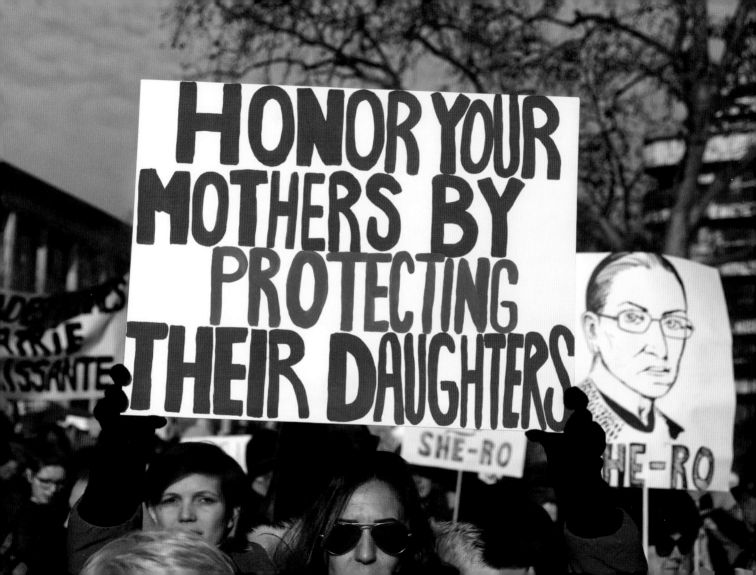

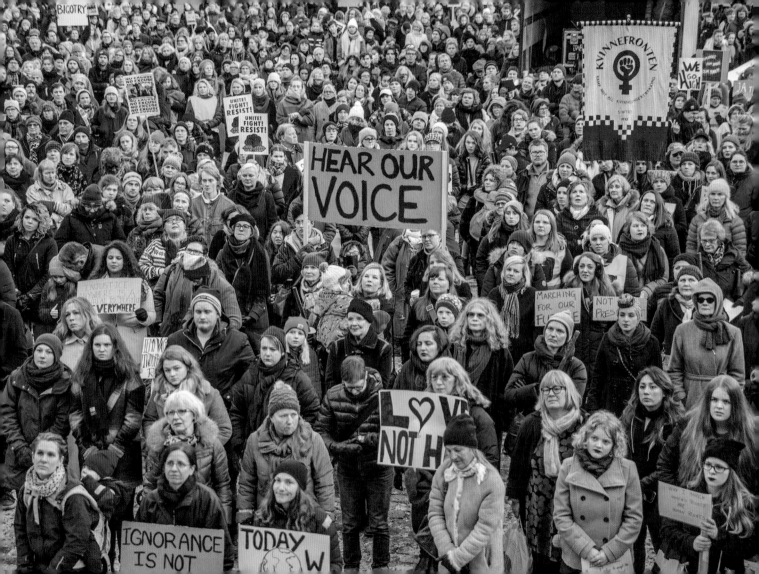

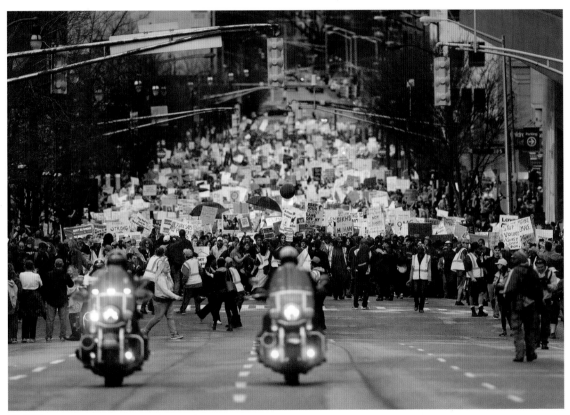

ATLANTA
OPPOSITE: OSLO

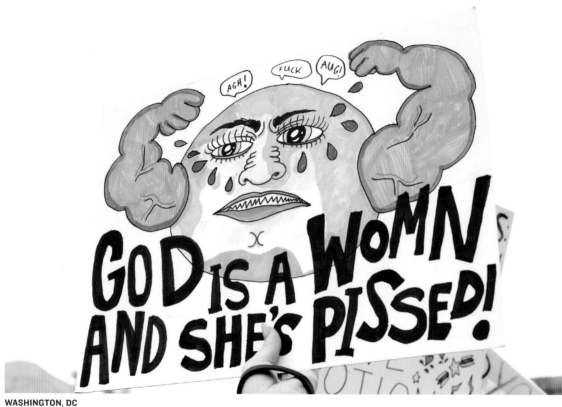

WASHINGTON, DC

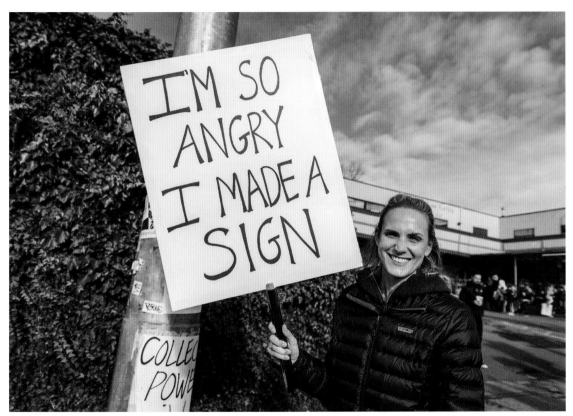

SEATTLE

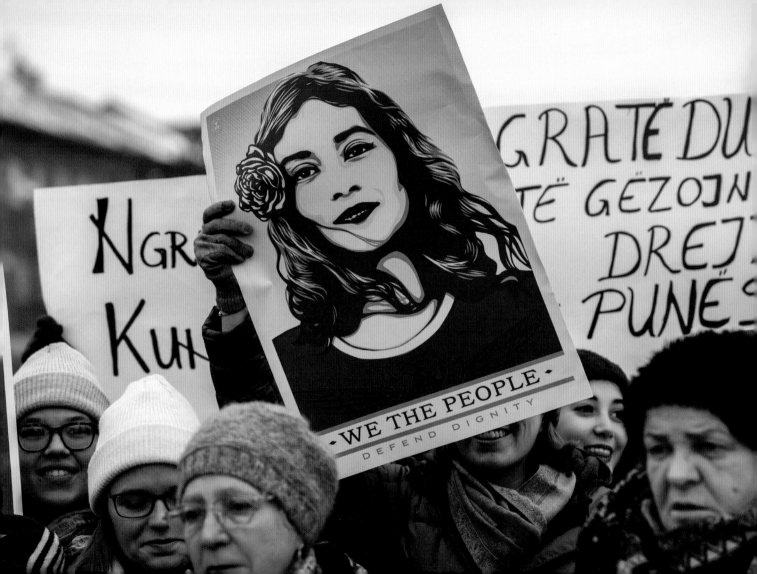

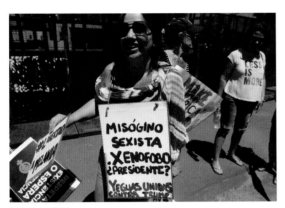

BUENOS AIRES

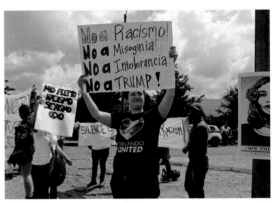

BOGOTÁ

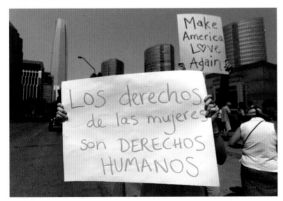

SANTIAGO
OPPOSITE: PRISTINA, KOSOVO

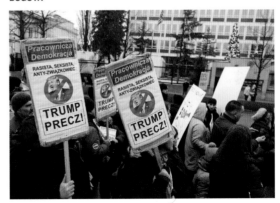

WARSAW

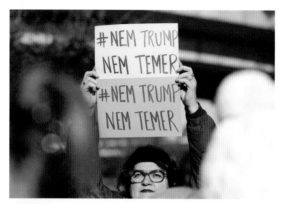

LISBON

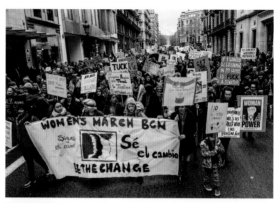

BARCELONA

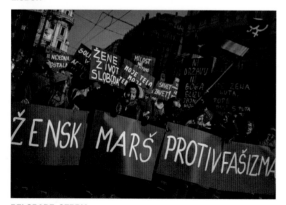

BELGRADE, SERBIA

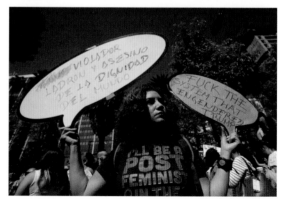

MEXICO CITY
OPPOSITE: BRASÍLIA

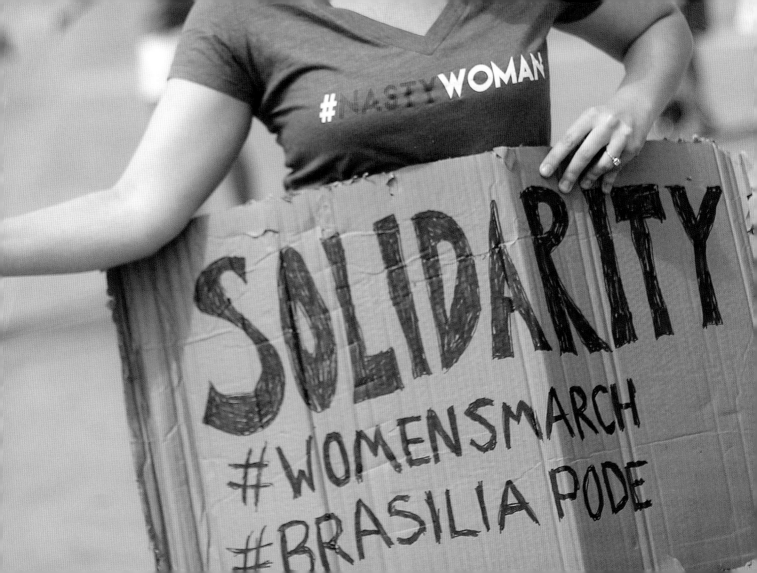

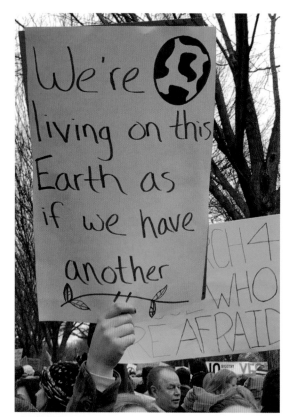

WASHINGTON, DC

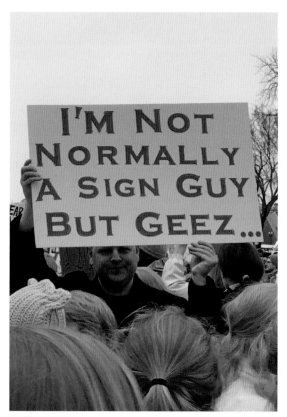

WASHINGTON, DC

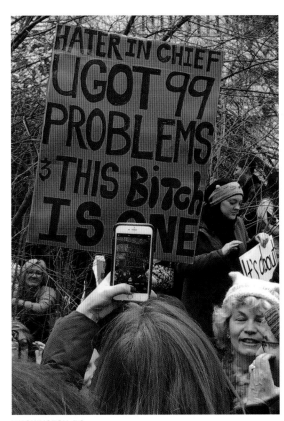

WASHINGTON, DC

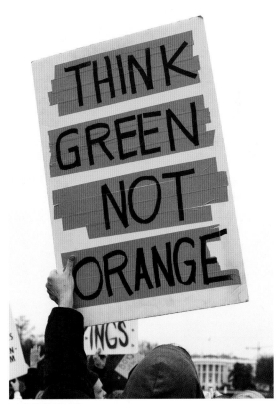

WASHINGTON, DC

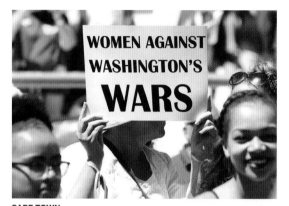

CAPE TOWN

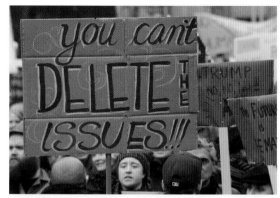

TORONTO

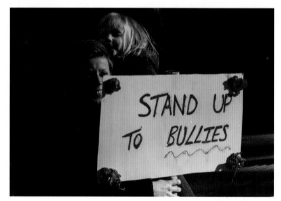

LONDON

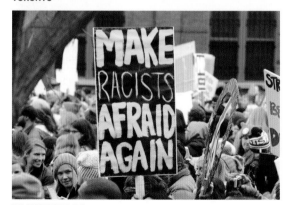

WASHINGTON, DC

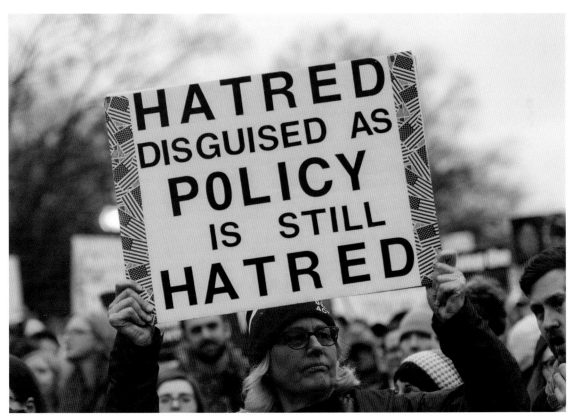

WASHINGTON, DC

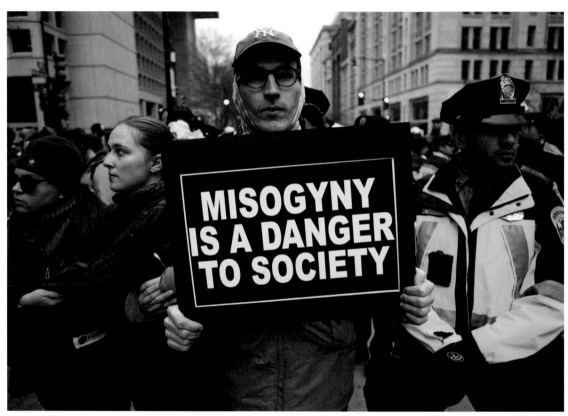

WASHINGTON, DC

"This is about you and me, standing up for our democracy and saying 'I matter.'"
—Kerry Washington

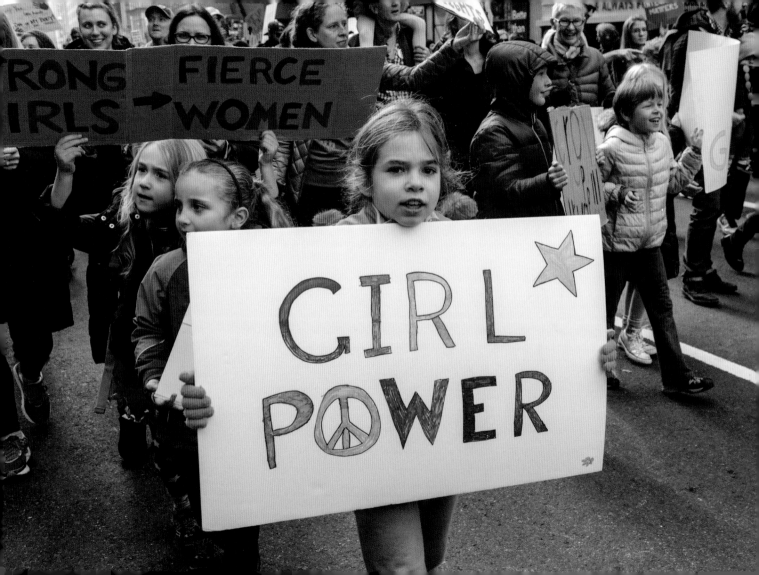

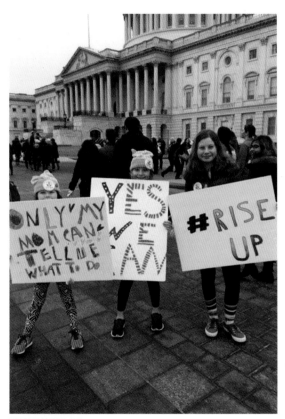

WASHINGTON, DC
OPPOSITE: NEW YORK CITY

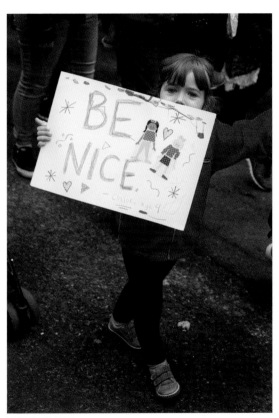

NEW YORK CITY

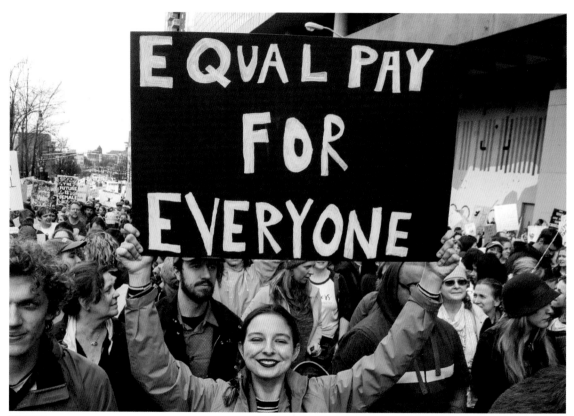

ATLANTA

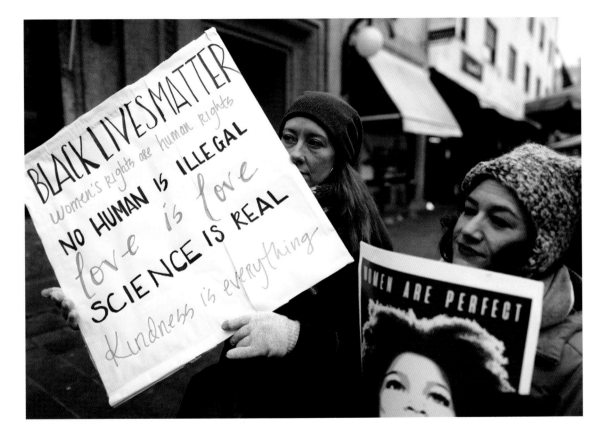

ZAGREB, CROATIA

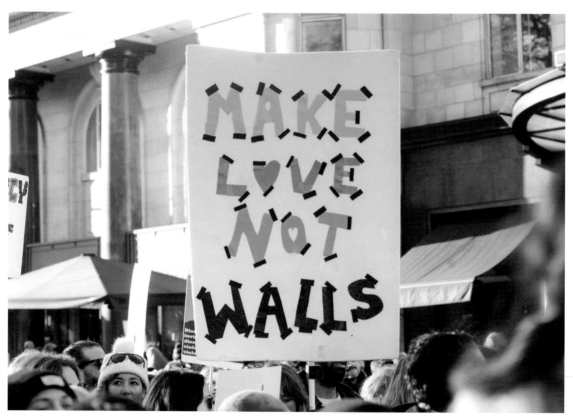

LONDON

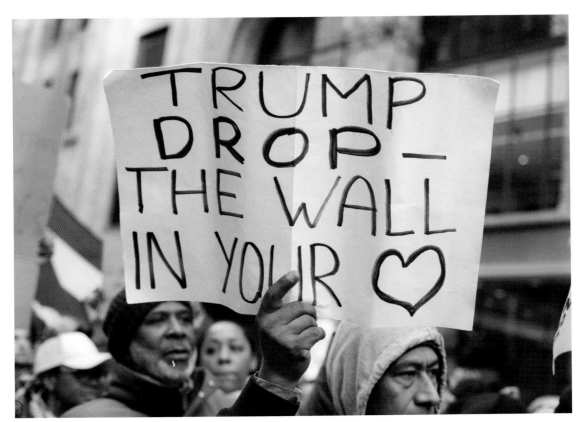

NEW YORK CITY

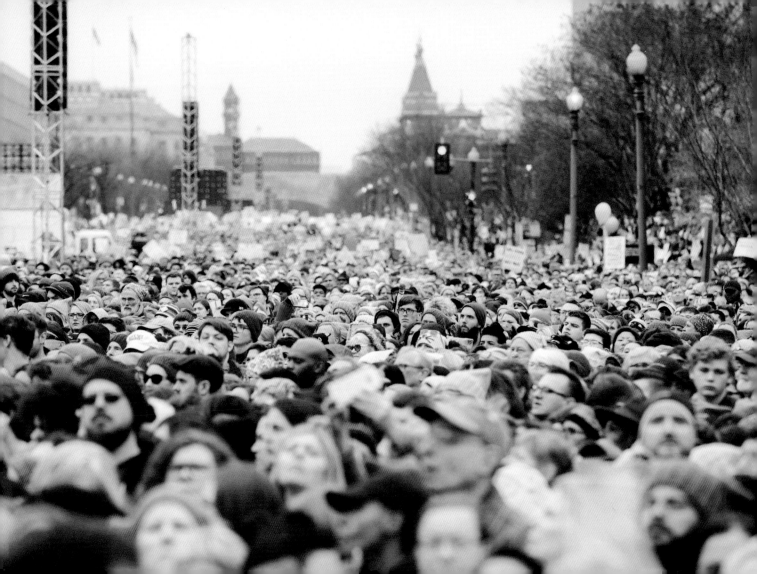

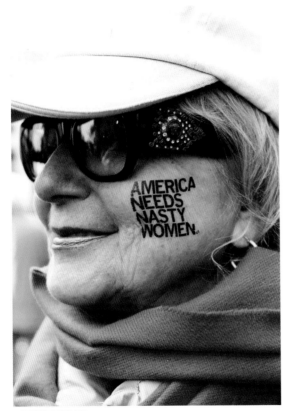

WASHINGTON, DC
OPPOSITE: WASHINGTON, DC

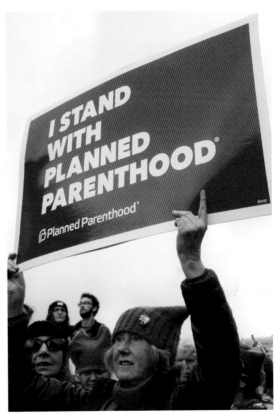

SAN FRANCISCO

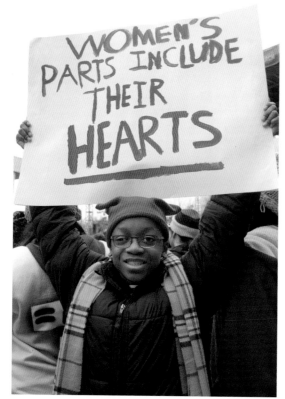

WASHINGTON, DC

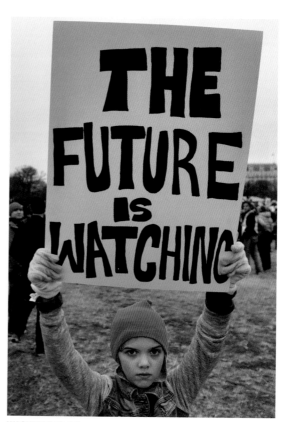

WASHINGTON, DC

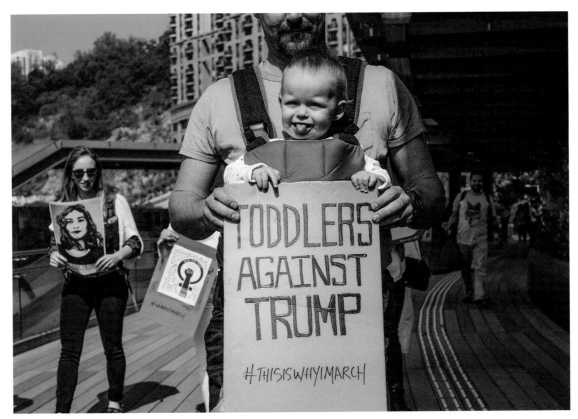

MACAU, CHINA

MARCHES IN THE UNITED STATES

Alabama
Birmingham
Mentone

Alaska
Anchorage
Bethel
Cordova
Fairbanks
Gustavus
Haines
Homer
Juneau
Ketchikan
Kodiak
Kotzebue
Nome
Palmer
Seldovia
Sitka
Skagway
Soldotna
Valdez

Arizona
Ajo
Flagstaff
Gold Canyon
Green Valley
Jerome

Phoenix
Prescott
Sedona
Tucson
Yuma

Arkansas
Bentonville
Fayetteville
Little Rock

California
Albany
Beverly Hills
Bishop
Borrego Springs
Carmel
Chico
Compton
Eureka
Fort Bragg
Fresno
Gualala
Hemet
June Lake
Kings Beach
Laguna Beach
Lompoc
Los Angeles
Modesto

Mount Shasta
Napa
Oakhurst
Oakland
Pacifica
Palmdale
Pasadena
Redding
Redondo Beach
Ridgecrest
Riverside
Sacramento
San Clemente
San Diego
San Francisco
San Jose
San Leandro
San Luis Obispo
San Marcos
Santa Ana
Santa Barbara
Santa Cruz
Santa Rosa
Seaside
Sonoma
Ukiah
Ventura
Visalia
Walnut Creek

Colorado
Alamosa
Aspen
Carbondale
Cedaredge
Colorado Springs
Cortez
Denver
Glenwood Springs
Grand Junction
Ridgway
Salida
Steamboat Springs
Telluride

Connecticut
East Haddam
Hartford
Old Saybrook
Salisbury
Stamford

Delaware
Newark

District of Columbia
Washington

Florida
Daytona Beach
Fernandina Beach

Gainesville
Jacksonville
Key West
Miami
Miami Beach
Naples
New Smyrna Beach
Ocala
Orlando
Panama City
Pensacola
Saint Augustine
Saint Petersburg
Sarasota
Tallahassee
West Palm Beach

Georgia
Atlanta
Augusta
Statesboro
Zebulon

Guam
Hagåtña

Hawaii
Hilo
Honolulu
Kahului
Kauai

Kawaihae
Kona
Lihue

Idaho
Boise
Driggs
Idaho Falls
Ketchum
Moscow
Pocatello
Sandpoint
Stanley

Illinois
Carbondale
Champaign
Chicago
Galesburg
Maryville
Peoria
Rockford
Springfield

Indiana
Fort Wayne
Greenwood
Indianapolis
Lafayette
Paoli

Saint Mary-of-the-Woods
South Bend

Iowa
Decorah
Des Moines
Dubuque
Harpers Ferry
Iowa City

Kansas
Topeka
Wichita

Kentucky
Lexington
Louisville
Murray

Louisiana
Lafayette
New Orleans
Shreveport

Maine
Augusta
Brunswick
Eastport
Kennebunk
Portland
Sanford

Surry
Vinalhaven

Maryland
Annapolis
Baltimore
Frederick
Ocean City

Massachusetts
Boston
Falmouth
Greenfield
Nantucket
Northampton
Pittsfield
Provincetown

Michigan
Adrian
Ann Arbor
Brighton
Clare
Detroit
Douglas
Grand Rapids
Grosse Pointe
Houghton
Kalamazoo
Lansing
Marquette

Merrill
Midland
Traverse City

Minnesota
Bemidji
Duluth
Longville
Morris
Rochester
Saint Paul

Mississippi
Gulfport
Hattiesburg
Jackson
Oxford

Missouri
Columbia
Kansas City
Saint Louis
Springfield

Montana
Helena
Miles City

Nebraska
Lincoln
Loup City
Omaha

Nevada
Las Vegas
Reno
Stateline

New Hampshire
Concord
Francestown
Jackson
Keene
Lancaster
Portsmouth
Wilton

New Jersey
Asbury Park
Pompton Plains
Sicklerville
Trenton
Westfield
Wyckoff

New Mexico
Albuquerque
Deming
Fort Sumner
Las Cruces
Santa Fe

New York
Albany
Binghamton

Buffalo
Cobleskill
Cooperstown
Delhi
Fredonia
Glens Falls
Hudson
Ithaca
Lewis
New York
Oneonta
Port Jefferson Station
Port Jervis
Poughkeepsie
Rochester
Sag Harbor
Seneca Falls
Syracuse
Utica
Watertown
Woodstock

North Carolina
Asheville
Black Mountain
Burnsville
Charlotte
Greensboro
Hillsborough
Mooresville
Morganton
New Bern
Raleigh
West Jefferson

Wilmington
Winston-Salem

North Dakota
Bismarck
Fargo
Grand Forks

Ohio
Chillicothe
Cincinnati
Cleveland
Dayton
Lakeside
Toledo
Troy
Wooster

Oklahoma
Oklahoma City

Oregon
Ashland
Astoria
Bend
Brookings
Coos Bay
Elkton
Eugene
Florence
Halfway
Joseph
La Grande
McMinnville
Newport

Pendleton
Portland
Salem
Sandy
Tillamook
Welches

Pennsylvania
Beaver
Doylestown
Erie
Harrisburg
Indiana
Lancaster
Lewisburg
Philadelphia
Pittsburgh
Reading
Selinsgrove
Sharon

Puerto Rico
Mayagüez
San Juan
Santurce
Vieques

Rhode Island
Providence

South Carolina
Charleston
Clemson
Columbia
Greenville

South Dakota
Pierre
Rapid City
Sioux Falls
Vermillion

Tennessee
Chattanooga
Jonesborough
Knoxville
Memphis
Murfreesboro
Nashville
Oak Ridge

Texas
Abilene
Alpine
Amarillo
Austin
Beaumont
Brownsville
Corpus Christi
Dallas
Denton
Eagle Pass
El Paso
Fort Worth
Houston
Lubbock
Marfa
Nacogdoches
San Antonio
Wichita Falls

U.S. Virgin Islands
Cruz Bay
Saint Croix
Saint John
Saint Thomas

Utah
Bluff
Kanab
Moab
Ogden
Park City
Saint George
Salt Lake City

Vermont
Killington
Montpelier

Virginia
Arlington
Charlottesville
Norfolk
Roanoke
Williamsburg
Winchester
Woodstock

Washington
Anacortes
Bainbridge Island
Bellingham
Chelan
Eastsound
Ephrata

Friday Harbor
Kingston
Langley
Longview
Mount Vernon
Olympia
Port Townsend
Richland
Seattle
Spokane
Twisp
Union
Walla Walla
Wenatchee
Yakima

West Virginia
Charleston

Wisconsin
Bayfield
Eau Claire
Madison
Menomonie
Milwaukee
Minocqua
Plymouth
Sheboygan

Wyoming
Casper
Cheyenne
Cody
Jackson
Lander
Laramie
Pinedale

INTERNATIONAL MARCHES

Antarctica
Paradise Bay

Argentina
Buenos Aires

Aruba
Noord

Australia
Canberra
Melbourne
Sydney

Austria
Vienna

Bahamas
Freeport

Belarus
Minsk

Belgium
Brussels

Bermuda
Hamilton

Bolivia
La Paz

Botswana
Gaborone

Brazil
Brasília
Ipanema

Bulgaria
Sofia

Canada
Balfour
Bowen Island
Calgary
Charlottetown
Edmonton
Fredericton
Gabriola
Grand Forks
Halifax
Hamilton
Kamloops
Kelowna
Kingston
Kootenay Bay
Lethbridge
London
Montreal
Nanaimo

North West River
Orangedale
Ottawa
Roberts Creek
Saint Catharines
Saint John
Saint John's
Salmon Arm
Salt Spring Island
Saskatoon
Sutton
Toronto
Vancouver
Victoria
Winnipeg
Yellowknife

**Caribbean
Netherlands**
Kralendijk

Cayman Islands
George Town

Chile
Santiago

China
Macau

Colombia
Bogotá
Manizales
Medellín

Congo
Kinshasa

Croatia
Zagreb

Costa Rica
Cahuita
Monteverde
Potrero
San José
Uvita

Czech Republic
Prague

Denmark
Copenhagen

Ecuador
Cuenca

Finland
Helsinki

France
Auvillar
Bordeaux
Marseille
Montpellier

Paris
Poitiers
Strasbourg
Toulouse

Georgia
Tbilisi

Germany
Berlin
Bonn
Düsseldorf
Frankfurt
Hamburg
Heidelberg
Munich

Ghana
Accra

Greece
Athens

Guatemala
Antigua

Hungary
Budapest

Iceland
Reykjavík

India
New Delhi

Indonesia
Bali
Gianyar
Kabupaten
Ubud

Iraq
Erbīl

Ireland
Castlebar
Dublin
Galway

Israel
Tel Aviv-Yafo

Italy
Florence
Milan
Rome

Japan
Osaka
Tokyo

Kenya
Nairobi
Turkana County

Kosovo
Pristina

Latvia
Riga

Lebanon
Beirut

Liberia
Monrovia

Lithuania
Vilnius

Macao
Taipa

Madagascar
Antananarivo

Malawi
Blantyre
Lilongwe

Mauritius
Beau Bassin–Rose
Hill

Mexico
Ajijic
Álamos
Campeche
Chetumal
El Sargento
La Manzanilla
Loreto
Mazatlán
Mexico City
Mérida
Nayarit

Oaxaca de Juárez
Playa del Carmen
San Miguel de Allende
San Pancho
Todos Santos
Tuxtla Gutiérrez
Zihuatanejo

Myanmar
Yangon

Netherlands
Amsterdam
The Hague
Roermond

New Zealand
Auckland
Christchurch
Dunedin
Wellington

Nicaragua
Managua

Nigeria
Jos

Norway
Bergen
Oslo
Trondheim

Peru
Chiclayo
Miraflores

Poland
Gdańsk
Kraków
Warsaw

Portugal
Angra do Heroísmo
Braga
Coimbra
Faro
Lisbon
Porto

Romania
Bucharest

Russia
Moscow

Rwanda
Kigali

Saint Kitts and Nevis
Charlestown

Saudi Arabia
Riyadh

Serbia
Belgrade

Singapore
Singapore

Slovakia
Piešťany

Slovenia
Ljubljana

South Africa
Cape Town
Cyrildene
Durban

South Korea
Seoul
Yeonsu-gu

Spain
Barcelona
Granada
Madrid

Sweden
Åre
Stockholm

Switzerland
Geneva

Tanzania
Dar es Salaam
Saadani

Thailand
Bangkok
Chiang Mai

United Kingdom
Bangor
Barnstaple
Belfast
Bristol
Cardiff
Edinburgh
Lancaster
Leeds
Liverpool
London
Manchester
Saint Austell
Shipley
Southampton
York

Uruguay
Montevideo

Vietnam
Hanoi

Zambia
Lusaka

Zimbabwe
Harare

PHOTOGRAPHY CREDITS

Getty Images: Pages 8 (JOSHUA LOTT/AFP/Getty Images), 10 (Jim Rankin/Toronto Star via Getty Images), 11 (top right: David Ramos/Getty Images; bottom right: Recep Sakar/Anadolu Agency/Getty Images), 13 (Amanda Edwards/FilmMagic/Getty Images), 16 (right: Steve Exum/FilmMagic/Getty Images), 17 (left: Wayne Taylor/Getty Images; right: Jessica Kourkounis/Getty Images), 18 (Derek Davis/Portland Press Herald via Getty Images), 23 (bottom left: Arindam Shivaani/NurPhoto via Getty Images), 27 (right: Cynthia Edorh/Getty Images), 34 (right: Amanda Edwards/FilmMagic/Getty Images), 35 (left: Amanda Edwards/FilmMagic/Getty Images), 36 (Amanda Edwards/FilmMagic/Getty), 37 (left: Steve Exum/FilmMagic/Getty), 38 (Don Arnold/Getty Images), 40 (top left: Wayne Taylor/Getty Images), 41 (bottom left: Jack Taylor/Getty Images), 43 (Bernard Menigault/Corbis via Getty Images), 44 (top right: Sarah L. Voisin/The Washington Post via Getty Images; bottom right: Owen Franken/Corbis via Getty Images), 52 (top left: Charlotte Ball/PA Images via Getty Images), 54 (John J. Kim/Chicago Tribune/TNS via Getty Images), 56 (bottom left: Barbara Alper/Getty Images), 57 (left: Michael Loccisano/Getty Images), 58 (ARMEND NIMANI/AFP/Getty Images), 64 (left: Michael S. Williamson/The Washington Post via Getty Images; right: Don Arnold/Getty Images), 66 (Scott Eisen/Bloomberg via Getty Images), 68 (top left: ANDREW CABALLERO-REYNOLDS/AFP/Getty Images), 72 (John Gress/Getty Images), 74 (left: Emma McIntyre/Getty Images), 75 (John Tlumacki/The Boston Globe via Getty Images), 77 (top right: Bernard Menigault/Corbis via Getty Images; bottom left: Amanda Edwards/FilmMagic/Getty Images), 78 (left: JASON CONNOLLY/AFP/Getty Images), 79 (left: Erik McGregor/Pacific Press/LightRocket via Getty Images), 80 (Karen Ducey/Getty Images), 82 (top left: Sergi Alexander/Getty Images; top right: Dean Mouhtaropoulos/Getty Images; bottom left: David Ramos/Getty Image; bottom right: David Mbiyu/Corbis via Getty Images), 84 (Christophe Morin/IP3/Getty Images), 90 (top right: Paul Morigi/WireImage/Getty Images), 91 (top right: Teresa Kroeger/FilmMagic/Getty Images), 95 (right: PEDRO PARDO/AFP/Getty Images), 97 (top left: Noam Galai/WireImage/Getty Images), 98 (ATTILA KISBENEDEK/AFP/Getty Images), 107 (Steffi Loos/Getty Images), 108 (left: Maddie Meyer/Getty Images), 110 (left: Kevin Mazur/WireImageGetty Images), 118 (Kevin Mazur/WireImage/Getty), 119 (Jason Connolly/AFP/Getty Images), 122 (Don Emmert/AFP/Getty Images), 125 (left: Chelsea Guglielmino/Getty Images; right: Amanda Edwards/FilmMagic/Getty Images), 126 (top right: Joe Amon/The Denver Post via Getty Images; bottom left: Jack Guez/AFP/Getty Images; bottom right: Jussi Nukari/AFP/Getty Images), 127 (top left: Esa Alexander/Sunday Times/Gallo Images/Getty Images; bottom right: Bernard Menigault/Corbis via Getty Images), 128 (Joe Amon/The Denver Post via Getty Images), 129 (Teresa Kroeger/FilmMagic/Getty Images), 133 (Mustafa Keles/Anadolu Agency/Getty Images), 140 (top left: CRISTINA ALDEHUELA/AFP/Getty Image; bottom right: Bryan Jaybee/Anadolu Agency/Getty Images), 141 (bottom left: Alex Milan Tracy/Anadolu Agency/Getty Images), 148 (Christophe Morin/IP3/Getty Images), 152 (right: Cynthia Edorh/Getty Images), 157 (left: CLAUDIO REYES/AFP/Getty Images), 159 (top left: ROBYN BECK/AFP/Getty Images; bottom right: Amanda Edwards/FilmMagic/Getty Images), 160 (right: Amanda Edwards/FilmMagic/Getty Images), 162 (right: Scott Eisen/Bloomberg via Getty Images), 167 (right: George Pimentel/Getty Images), 168 (Christophe Morin/IP3/Getty Images), 170 (Maddie Meyer/Getty Images), 173 (right: Amanda Edwards/FilmMagic/Getty Images), 174 (Amanda Edwards/FilmMagic/Getty Images), 176 (Noam Galai/WireImage/Getty Images), 177 (Erik McGregor/Pacific Press/LightRocket via Getty Images), 178 (bottom left: Joe Amon/The Denver Post via Getty Images), 179 (Bernard Menigault/Corbis via Getty Images), 184 (bottom left: Tayfun Coskun/Anadolu Agency/Getty Images; bottom right: Steve Exum/FilmMagic/Getty Images), 188 (bottom left: Noam Galai/WireImage/Getty Images), 194

Danny Rothenberg/Polaris), 214 (top left: Natan Dvir/Polaris Images), 216 (bottom left: Christopher Brown/Polaris), 223 (bottom left: Randy Rasmussen/Polaris), 225 (Sam Simmonds/Polaris), 228 (left: Stephen Shames/Polaris), 240 (bottom right: Sam Simmonds/Polaris), 251 (right: Jessica Brandi Lifland/Polaris), 252 (left: Rebecca Nowalski/Polaris).

Redux: Pages 23 (bottom right: Susannah Ireland/eyevine/Redux), 25 (Tiffany Brown Anderson/Redux), 26 (bottom left: Scott Witter/Redux; bottom right: Annabel Clark/Redux), 40 (bottom right: OLIVER WEIKEN/EPA/Redux), 42 (MAURIZIO BRAMBATTI/EPA/Redux), 44 (bottom left: Radhika Chalasani/Redux), 45 (Annabel Clark/Redux), 46 (left: Radhika Chalasani/Redux), 52 (bottom right: Craig Ruttle/Redux), 67 (left: Henny Garfunkel/Redux), 68 (top right: Sasha Maslov/Redux; bottom right: Jess HURD/REPORT DIGITAL-REA/Redux), 74 (right: Sasha Maslov/Redux), 76 (top right: Alyson Aliano/Redux), 77 (top left: Annabel Clark/Redux), 78 (right: Sasha Maslov/Redux), 81 (Annabel Clark/Redux), 85 (Jess Hurd/REPORT DIGITAL-REA/Redux), 86 (Scott Witter/Redux), 87 (Annabel Clark/Redux), 91 (bottom left: William B. Plowman/Redux), 94 (left: Jess Hurd/REPORT DIGITAL-REA/Redux), 97 (top right: Ruth Fremson/The New York Times/Redux; bottom right: Radhika Chalasani/Redux), 101 (Branden Eastwood/Redux), 102 (top right: ABIR SULTAN/EPA/Redux), 104 (Branden Eastwood/Redux), 105 (Sabine Joosten/Hollandse Hoogte/Redux), 111 (left: Branden Eastwood/Redux), 112 (Henny Garfunkel/Redux), 117 (Radhika Chalasani/Redux), 126 (top left: William B. Plowman/Redux), 127 (bottom left: Xavier Popy/REA/Redux), 137 (right: Elke Bock/laif/Redux), 140 (top right: Juliette ROBERT/HAYTHAM-REA/Redux), 144 (right: Henny Garfunkel/Redux), 145 (Anna Watson/Camera Press/Redux), 147 (top left: Sabine Joosten/Hollandse Hoogte/Redux; top right: Elke Bock/laif/Redux), 158 (Scott Witter/Redux), 159 (top right: Jess HURD/REPORT DIGITAL-REA/Redux), 167 (left: Radhika Chalasani/Redux), 169 (Radhika Chalasani/Redux), 173 (left: Jess Hurd/REPORT DIGITAL-REA/Redux), 178 (top left: Annabel Clark/Redux; top right: Henny Garfunkel/Redux; bottom right: Mark Peterson/Redux), 180 (Susannah Ireland /eyevine/Redux), 188 (top right: Sarah Blesener/Redux), 189 (top left: Henny Garfunkel/Redux; bottom left: Al Drago/The New York Times/Redux), 190 (right: Annabel Clark/Redux), 206 (bottom left: Sasha Maslov/Redux), 211 (left: Annabel Clark/Redux), 212 (bottom left: Xavier POPY/REA/Redux), 214 (bottom left: Branden Eastwood/Redux), 221 (Scott Witter/Redux), 223 (top right: Lionel Preau/Riva Press/Redux), 227 (Laura Kleinhenz/Redux), 235 (top right: Leonardo Muñoz/EPA/Redux), 236 (bottom right: Sashenka Gutierrez/EPA/Redux), 242 (Radhika Chalasani/Redux), 250 (Laura Kleinhenz/Redux).

Alamy: Pages 34 (left: MediaPunch Inc/Alamy Live News), 65 (Patsy Lynch/Alamy), 76 (bottom right: Brian William Waddell/Alamy).

Shutterstock: Pages 61 (vinzow/Shutterstock), 210 (Philip Pilosian/Shutterstock).

Individual photographers: Pages 44 (top left: Jake Chessum), 52 (bottom left: Lillian Silver), 88 (Cynthia Reed), 89 (Jake Chessum), 90 (top left: Walter Smith; bottom left: Jackson Krule), 91 (top left: Jake Chessum; bottom right: Sara Luckey), 111 (right: Andrew Himmelberg), 113 (right: Rockie Nolan), 114 (left: Robin Takami), 121 (left: Courtesy Jenny Sowry), 124 (left: Sara Luckey), 130 (Courtesy Linda Zunas), 131 (Courtesy Linda Zunas), 137 (left: Sara Luckey), 140 (bottom left: Sara Luckey), 141 (bottom right: Sara Luckey), 156 (left: Melissa Renwick), 181 (left: Sara Luckey), 187 (Judy Pray), 189 (top right: Angela Campbell), 191 (left: Jon Feinstein), 195 (Walter Smith), 198 (Sara Luckey), 201 (left: Elissa Maran Bean), 209 (right: Sara Luckey), 212 (top right: Lucinda Scala Quinn; bottom right: Rockie Nolan), 213 (Nathalie Le Du), 216 (top left: Theresa Scarbrough; bottom right: Sara Luckey), 219 (Sara Luckey), 226 (top left: Maureen Karb Laguarta), 238 (left and right: Lia Ronnen), 239 (left: Lia Ronnen), 245 (left: Naria Halliwell; right: Sara Luckey), 249 (Sara Luckey).

March on!